Low 'n slow
LOWRIDING IN NEW MEXICO

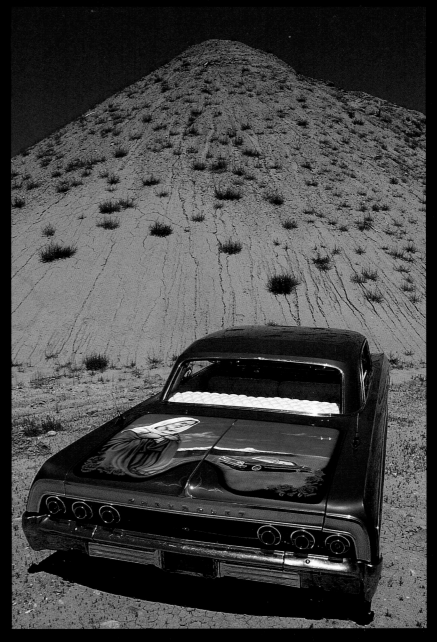

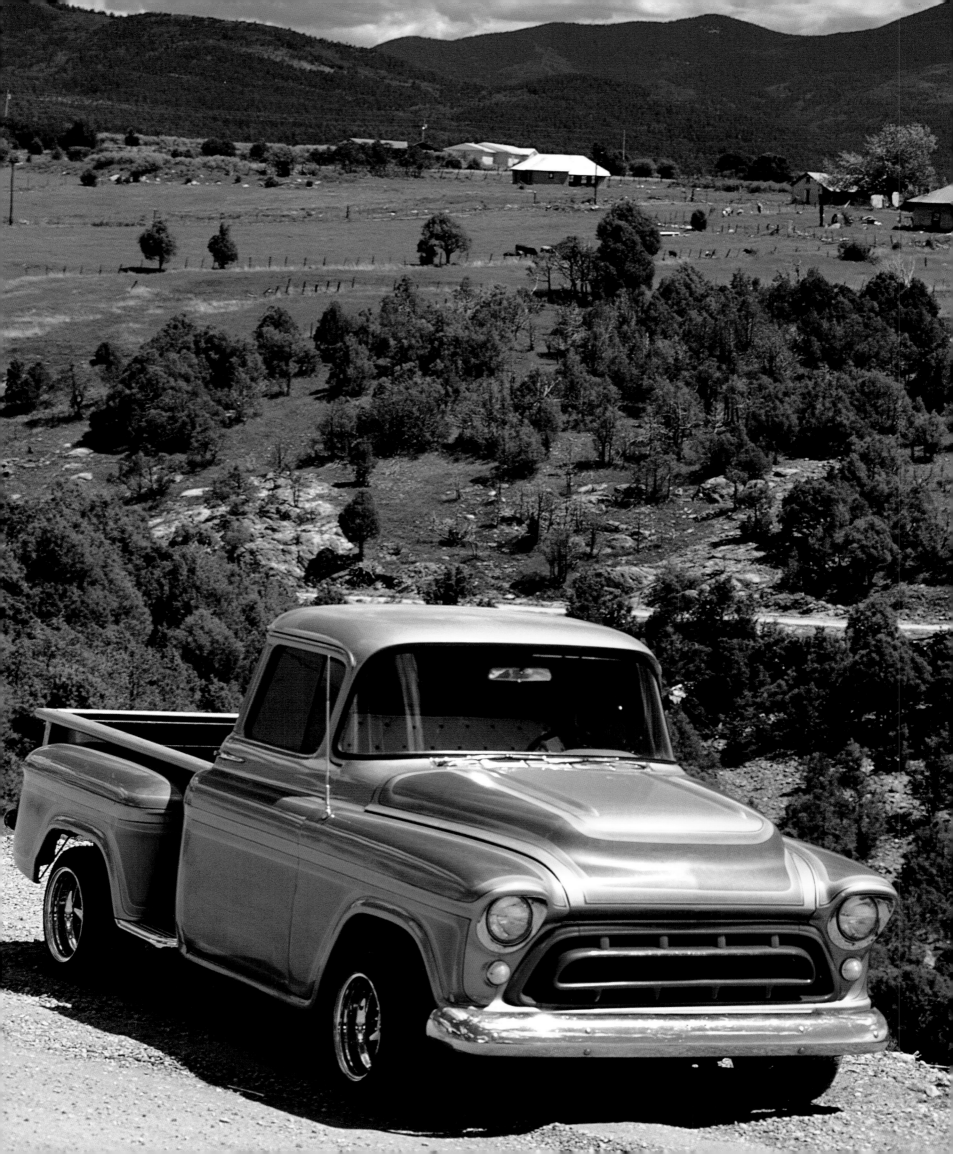

Low 'n slow

LOWRIDING IN NEW MEXICO

PHOTOGRAPHS BY JACK PARSONS
TEXT BY CARMELLA PADILLA
POETRY BY JUAN ESTEVAN ARELLANO

MUSEUM OF NEW MEXICO PRESS
SANTA FE

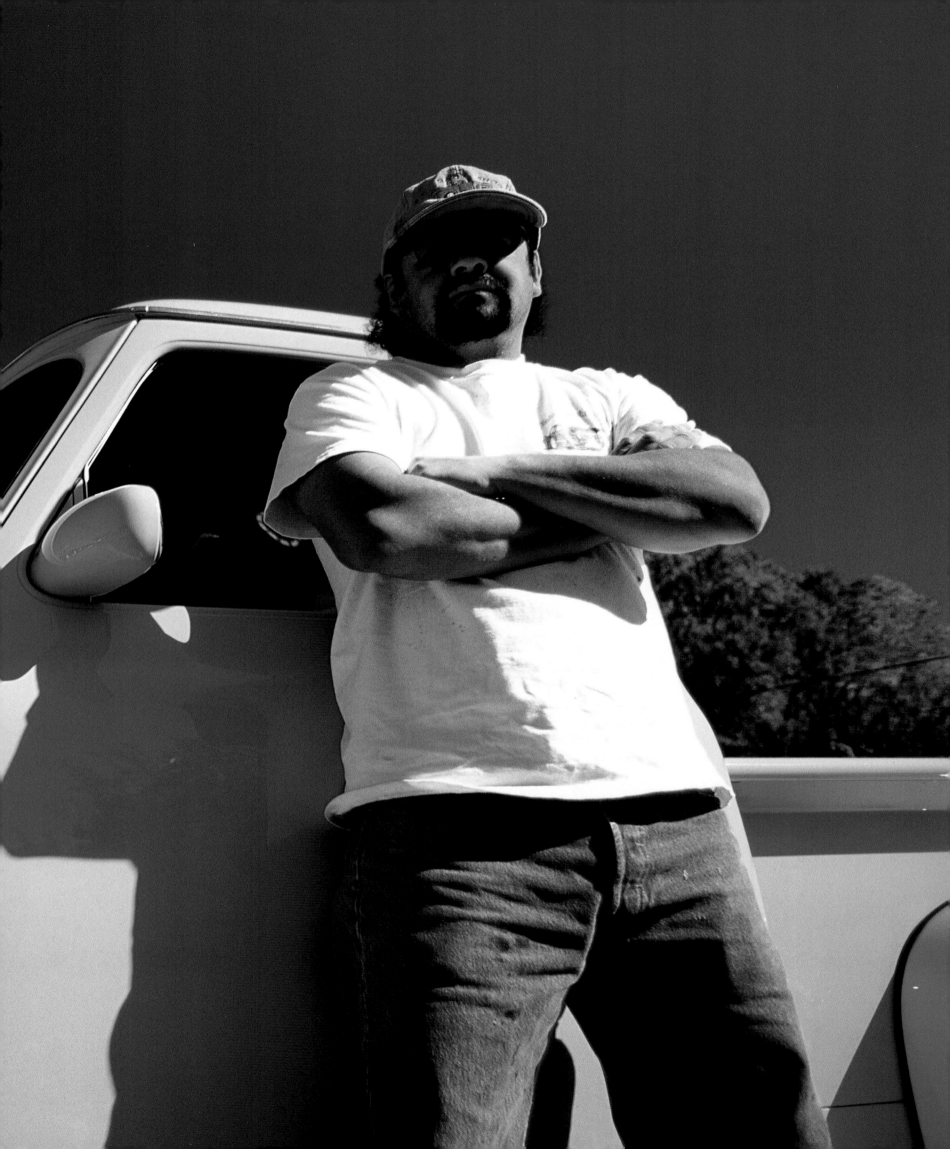

For Patrizia, who got me started,
and for Becky, Chris, and Alex.

With Love,
Jack

For Luis,
whose lowrider knowledge and unwavering support helped
me maneuver many rocky roads throughout this project.

Con Amor,
Carmella

Project Editor: Mary Wachs
Designer: David Skolkin
Typeset in Bauer Bodoni with Snell display
Manufactured in China at C+C Offset Printing Co.. Ltd.

10 9 8 7 6 5 4 3 2

Library of Congress Cataloging-in-Publication Data

Parsons, Jack, 1939-
 Low 'n slow : lowriding in New Mexico / photographs by Jack Parsons ; text by Carmella Padilla : three poems by Juan Estevan Arellano.
 p. cm.
 ISBN 0-89013-372-7. – ISBN 0-89013-373-5 (pbk.)
1. Mexican Americans—New Mexico—Social life and customs—Pictorial works.
2 Mexican-Americans—New Mexico—Social life and customs. 3. Lowriders—New Mexico—Pictorial works. 4. Lowriders—New Mexico. 5. New Mexico—Social life and customs—Pictorial works. 6. New Mexico—Social life and customs. I. Padilla, Carmella. II Arellano, Juan Estevan. III. Title.
 F805.M5P37 1999 98-31198
 978.9'0046872073—dc21 CIP

MUSEUM OF NEW MEXICO PRESS
POST OFFICE BOX 2087
SANTA FE, NEW MEXICO 87504

page i
'64 Chevy Impala
Owner Eddie Gallegos of El Llano

page ii
'57 Chevy pickup
Owner Dean Tafoya of Truchas

page iv–v
'54 Ford F100
Owner Clarence Pacheco of Santa Fe

Contents

The Cruise 9

¡Dale Gas! (Give It Gas!) 15

Interview with a Lowrider 27

Ode to "el mecánico" 30

La Virgen de Guadalupe Cruising down Chimayó 76

La eché en un Carrito 92

Acknowledgments 120

'52 Chevy Fleetline
Owner Floyd Montoya of Córdova

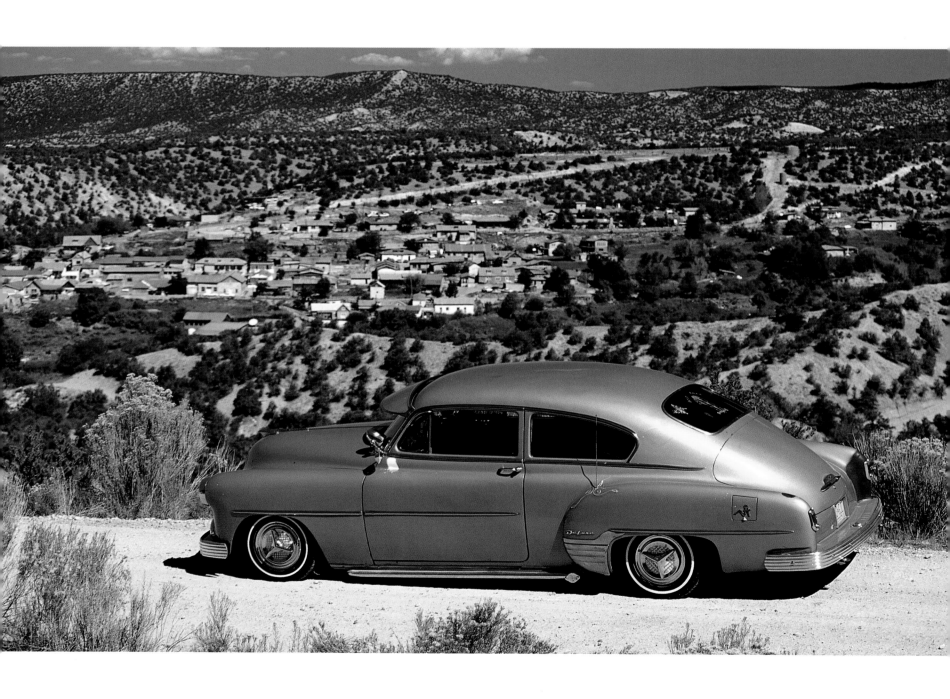

Whoooosh.

A balmy, midmorning breeze streams in through the side windows of Floyd Montoya's 1952 Chevrolet Fleetline as he drives at a steady 40-mile-per-hour cruise. After briefly lifting his hands off the steering wheel to adjust his beret, Montoya rests his left elbow upon the open window frame and relaxes his right steering hand into an easy grip. Tattooed biceps bulge beneath the sleeveless shoulders of Montoya's clean white T-shirt, and a gray string of a goatee hangs from his chin. A rosary, green-and-white dice, and various other knickknacks swing from the rearview mirror as the proud pilot gracefully rounds a curve and surveys the landscape before him. All along the hilly roadside, majestic stands of spruce, ponderosa pine, and fir stretch heavenward like pillars holding up the sky.

"If the sun shines and the highway is open, you can bet somebody's going to be out cruising," Montoya says. "This is my everyday car; I cruise it everywhere. I go to Santa Fe, Española,

Albuquerque, to Denver. I've been all the way to Elkhorn, Nevada, in it."

On this August morning, Montoya is cruising along New Mexico State Highway 76—the "high road" to Taos—from his home in the mountain village of Córdova. Destination: Chimayó, a scant four miles southwest. One doesn't have to go far, Montoya explains, to reap the benefits of a cruise. Any drive is worth it, he says, when you're going "low and slow."

"How can I describe the feeling I have when I'm in my lowrider?" Montoya continues, switching on the oldies station. He turns the volume up enough to where the wind doesn't drown out the music and the music doesn't interrupt the conversation. "It's like everything in the world stays behind me when I'm going forward in my car."

Ever since 1987, when he tumbled two stories down an elevator shaft, breaking his back and disabling him for life, Montoya has had good reason to want to leave parts of his world behind. The pain and inactivity sent him into a depression made worse by his dependence on alco-

hol. But once he stopped drinking and started working with cars again, he found reason to move ahead. To date he has redone some twenty cars in all.

"I'm really thankful to God for giving me this trade because it has really helped keep me going in the hard times," he says. "It gives me a feeling of accomplishment. It keeps me going in the right direction."

Montoya had just restored the '52 Fleetline at the time of his accident. He replaced its original parts with everything from power disk brakes and power tilt steering to a push-button starter. "All the goodies of a modern car," he says. Then, he lowered the car as low as it would go.

"My thing has always been to get a Chevy, make it the lowest lowrider I can make, and fix it up till it rides like a Cadillac," he says. "This is it. I call it my Chevylac."

The horn from an approaching automobile momentarily interrupts Montoya as a carload of shrieking teenagers streaks past. He waves and returns the honk, only to be greeted by another horn blast and a thumbs-up

signal from the driver of the car next in line.

"Every time I go out in this, there's nobody that doesn't wave at me," Montoya says with pride. "When I go to Santa Fe, around the old plaza, there's people snapping pictures of me all over the place. I enjoy people noticing my car. It makes me feel kind of special."

Montoya suddenly veers off the sloping road into the dirt parking place in front of La Mesa del Rincon, a tiny drive-up café *cum* mobile home. He leaves the engine humming as he walks to the window to order a couple of Cokes. Then, he carefully folds himself back into the car so the sodas don't spill, turns the car around, and starts back up the road.

Heading north now toward Truchas, the highway grows increasingly steep, prompting Montoya to gun the engine in preparation for the ascent. He races the car for a stretch before resuming a slow cruise and launching into his vision for the future:

"Little kids come around my house to see my car and I try to get them interested because what else is there for them? I tell them that one day, if they want to get into this, that maybe I can help them express themselves. Because that's what makes New Mexico lowriders unique: Everybody's got their own style. Some people like hydraulics, some don't. But everybody does their own thing."

Montoya goes silent now and for the next few minutes just stares straight ahead and drives. The sounds and rhythms of the roadway merge into a strangely soothing lullaby. Nearing the Córdova exit, he shifts his dreamy gaze toward home. As he leaves the highway asphalt for the dusty village road, he sighs.

"One day, if the Lord gives me the time, I plan to cruise this car for three months straight," he says. "I plan to just keep driving without ever coming home."

'63 Ford Thunderbird
Owner Floyd Montoya of Córdova.
Mural by Alexander Rokoff, concept by Jeremy Morelli.

left
detail from Montoya's '52 Chevy Fleetline

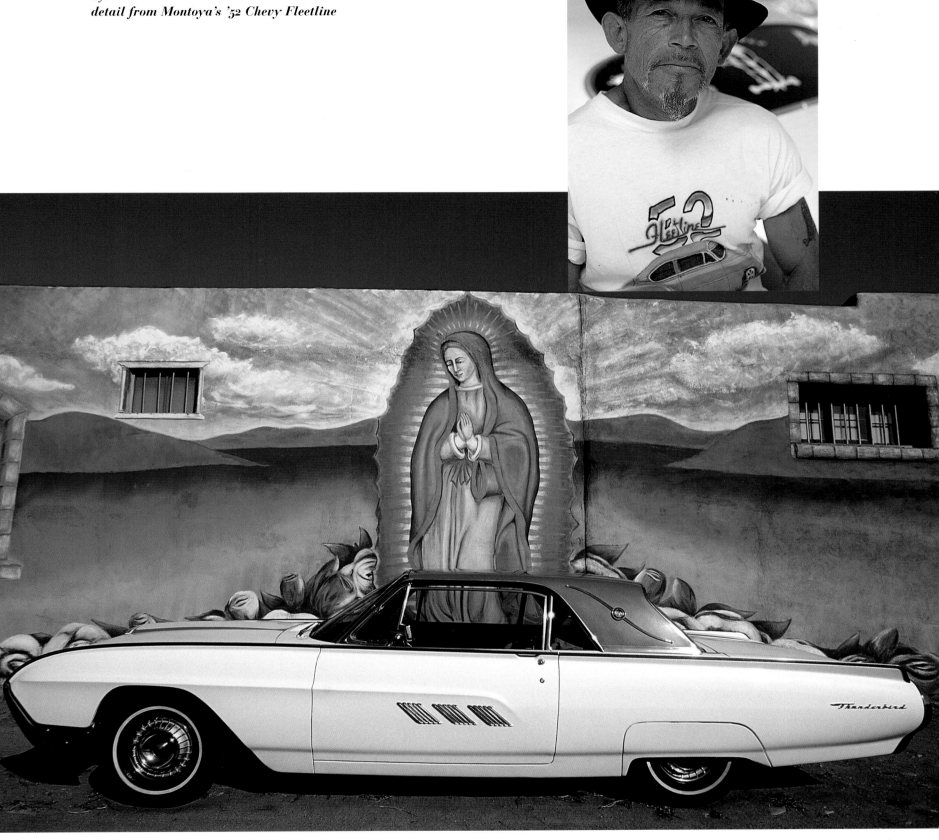

right
'78 Ford Thunderbird
Owner Joseph Martinez of Fairview.
Mural by Randy Martinez.

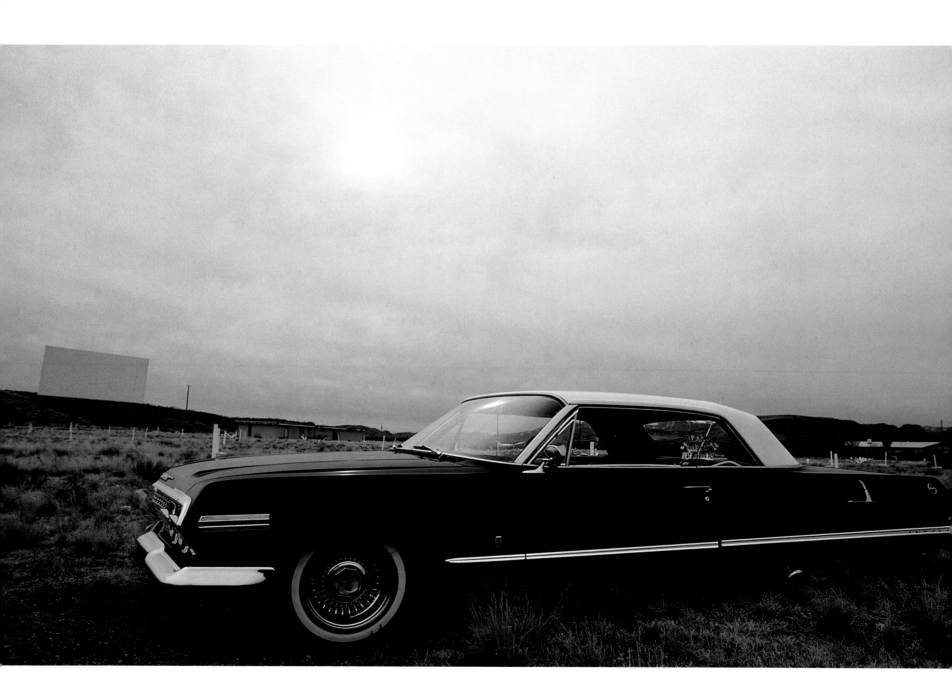

'63 Chevrolet Impala
Owner Carlos Carrillo of Socorro

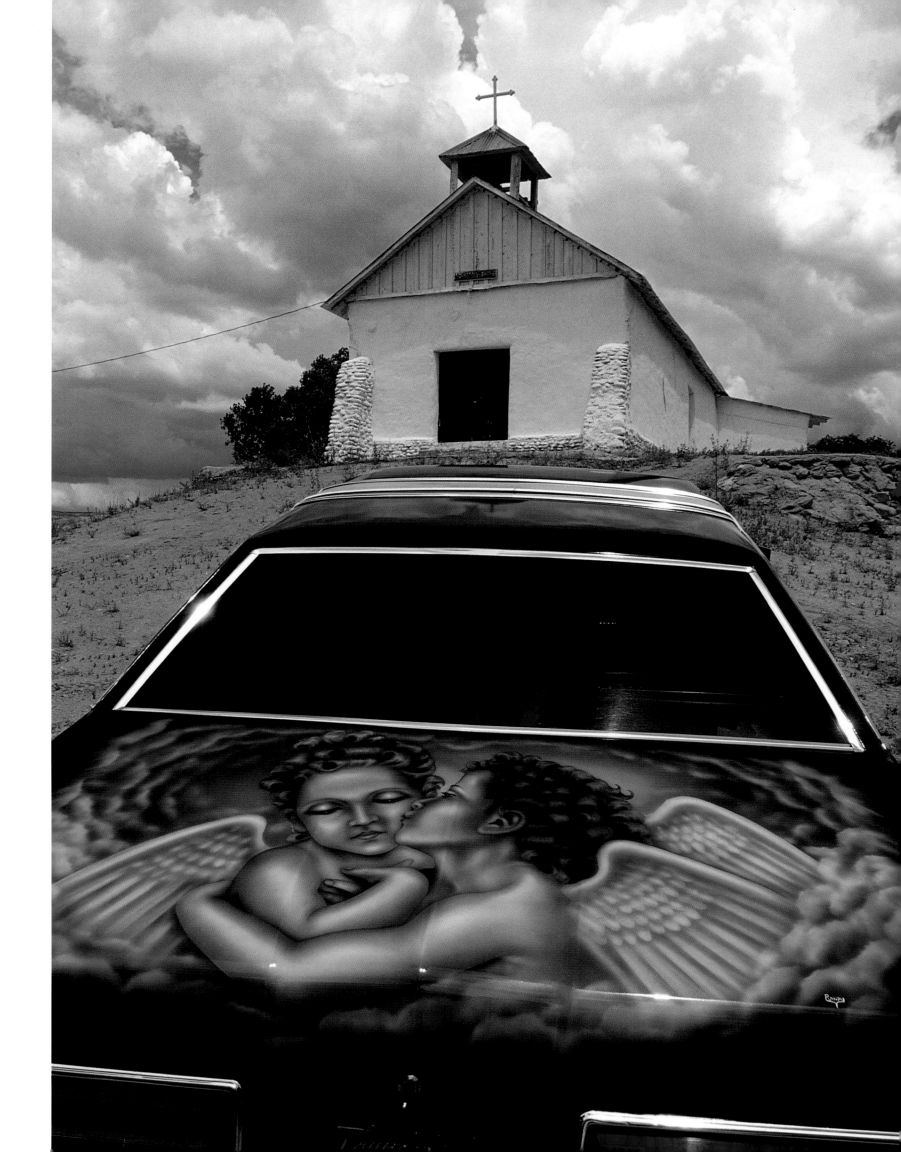

The late Nick Gallegos and son,
Antonio, of Española

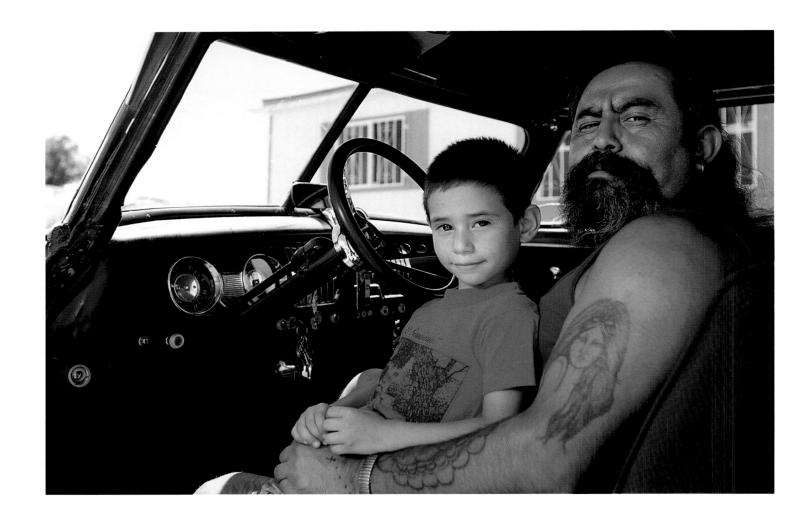

The light turns from yellow to red, bringing the midafternoon traffic to a halt. Side by side they sit in the middle of town waiting for the light to change, engines idling, tail pipes shooting exhaust into the dry summer air. The scene is quiet, almost serene, until a long, low '73 Cadillac glides to a stop beside another low-bodied classic. The drivers peer at each other through open side windows, then turn to watch the light turn green.

The light changes, giving the adjacent lowriders their much-anticipated cue. In an instant, the silence is swallowed up by the sound of the engines' thunder as the cars shift into gear and begin an arc of spectacular gyrations. Jumping, jerking, and jolting in great spasms of metal and glass, the cars convulse down main street. Then, their automatic hydraulics switched to off, they resume their fluid cruise down the roadway.

Welcome to Española, New Mexico, the self-proclaimed "Lowrider Capital of the World." It is here in this small town of nearly fifteen thousand that lowriders from across Northern New Mexico have for decades converged. Los Angeles may have Whittier Boulevard, and San José the intersection of Story and King, but Española has Riverside Drive, the undisputed main drag of the lowrider nation.

If the word "lowrider" were to be found in the dictionary (and usually it is not), it would be defined as a noun that describes either a car whose suspension has been altered in order to lower its body only inches from the ground or one who drives such a car. Beyond the literal definition the lowrider lexicon holds a host of underlying meanings and themes that helps to explain the cultural context in which the cars thrive. From such fundamentals as faith and family to concepts as subjective as art or as exact as economics, New Mexico's lowrider phenomenon rests upon a broad foundation of culture, creativity, and community. Although it shares common ground with the car cultures of Los Angeles or San Antonio, and with the international markets they feed, Northern New Mexico has become a hub for some of the most distinctive custom cars in the United States.

The uniqueness of New Mexico's lowriders was affirmed in 1992 when curators from the Smithsonian Institution saw fit to put a Chimayó lowrider on permanent exhibit in the National Museum of American History. Such institutional recognition was more than overdue for a modern expression of a culture that for centuries has based its survival on innovation, creativity, and skill.

The New Mexico lowrider community is a diverse group of men, women, and children bound together by a desire to transform ordinary, often dilapidated cars into grandiose works of art. From the body shop to the hydraulics shop to the mechanic's garage, the upholsterer's scissors to the painter's brush, from neon bumper to spoked hubcap to gold-plated grill, a lowrider is the product of the work of everyday individuals whose peculiar passion has made them accomplished engineers of metal, glass, and chrome. Their creations are personal expressions of individual taste as well as of the values of their communities and culture. Collectively, they have taken the automobile further than Henry Ford ever dreamed.

The New Mexican lowrider legion is comprised primarily of Hispanics who live in the small villages and towns that their Spanish, Mexican, and Native

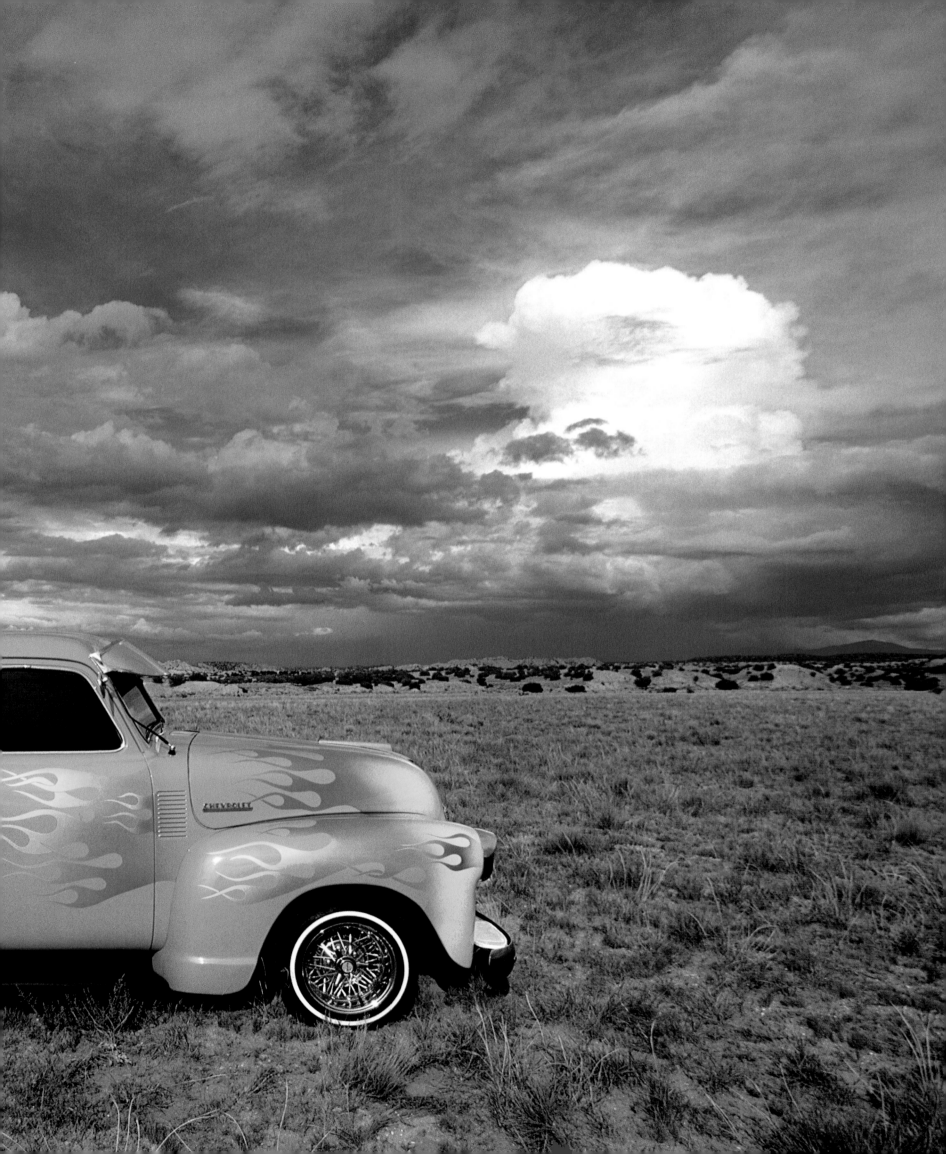

right
'50 Chevrolet Fleetline
Owner Jerome Reynolds of Alcalde.
Mural by Randy Martinez.

'63 Chevy Impala Super Sport
Owner David Lopez of Socorro

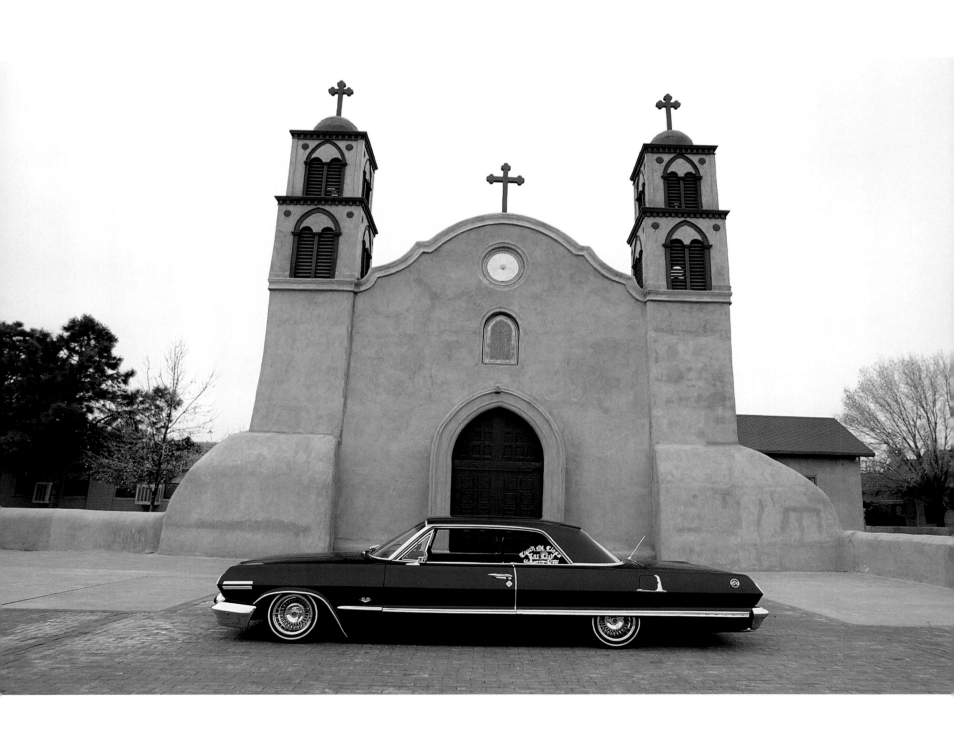

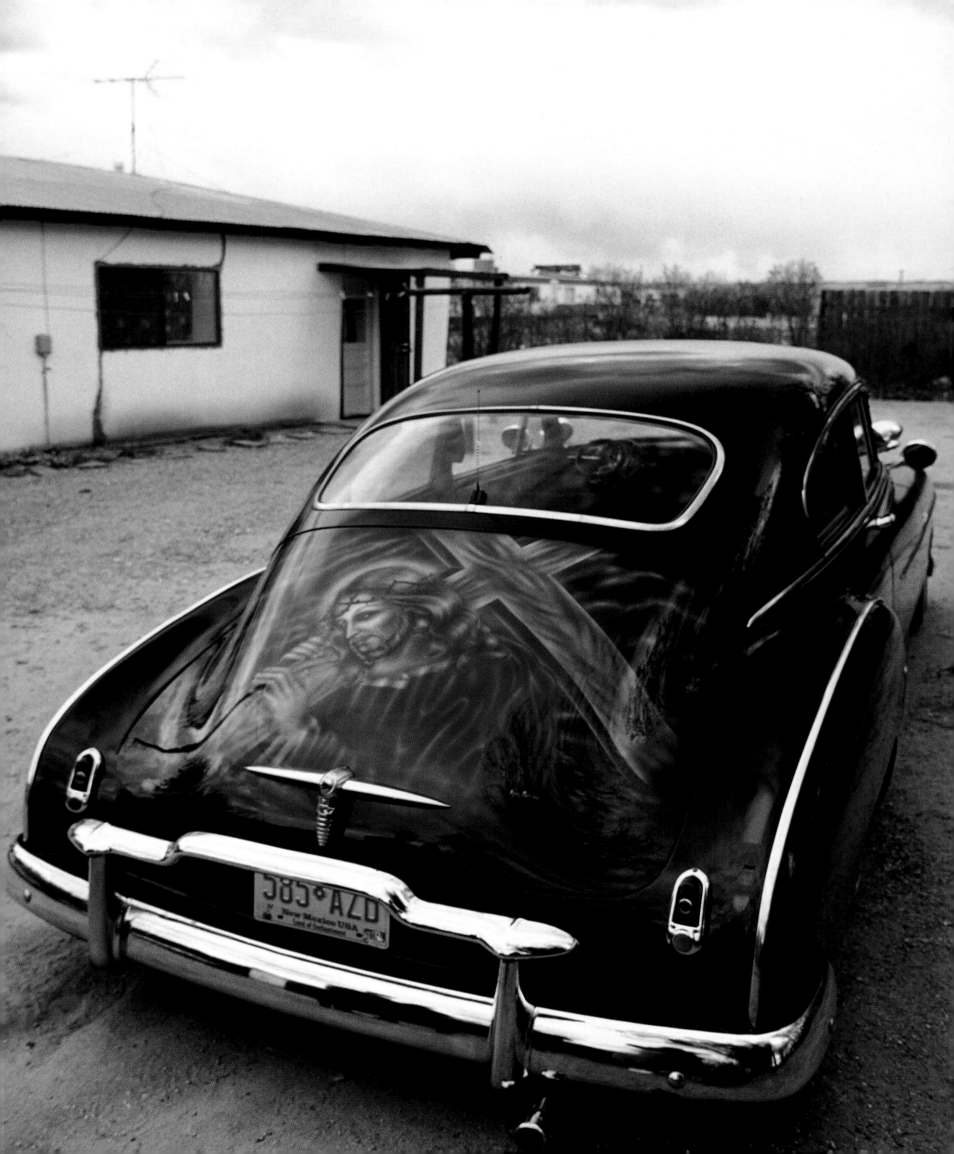

'51 Chevy Coupe (left)
Owner Leroy Trujillo of Chimayó

'52 Chevy hardtop
Owner Vince Trujillo of Chimayó

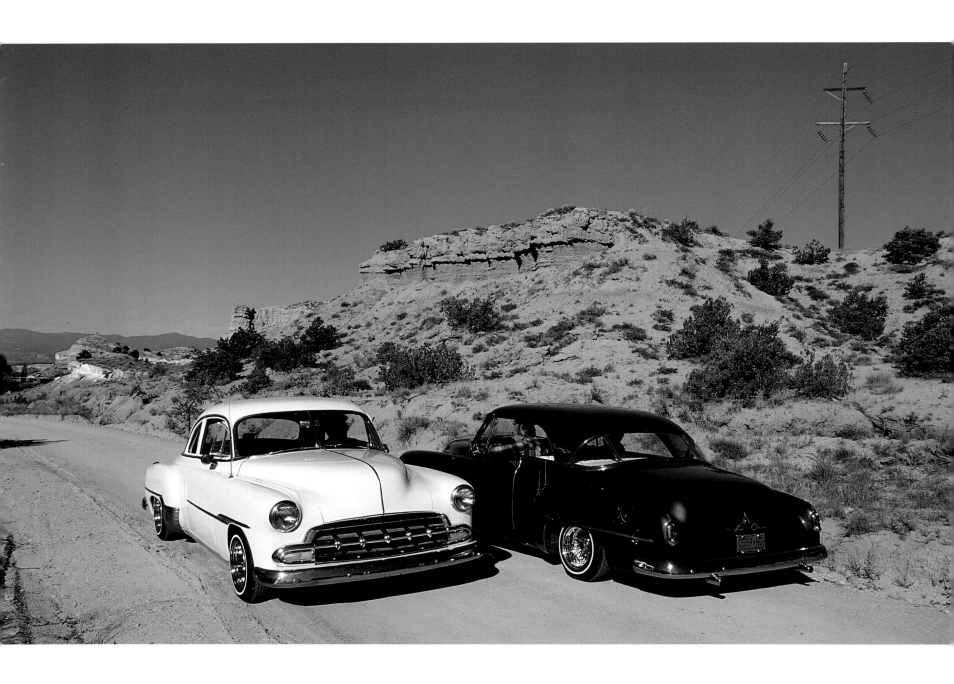

Interview with a Lowrider
Carmella Padilla
Juan Estevan Arellano

Northern New Mexico has a unique Spanish dialect that has been spoken and has evolved in our towns and villages since the late sixteenth century. It is kept alive and vivid in the "Spanglish" language of Northern New Mexico's lowrider culture, as expressed in the work of poet Juan Estevan Arellano.

PADILLA: *Orale*, Estevan. That's a term that I hear all the time among lowriders in Northern New Mexico. Can you explain it?

ARELLANO: *Orale* is a greeting, slang for "hello." In some senses, it can mean "pay attention." They use it here, but they use it in Mexico a lot, too. I've even heard it in Spain.

PADILLA: In your poem *La eché en un Carrito*—you refer to a *Carrito Paseado*. What is that?

ARELLANO: Oh, that comes from a song about lowriders. A *carrito paseado* is a "cruiser" that *la plebe, el vato loco*, or a *chavalo*—which all mean "young kid"— would be cruising in. Other kids are known as *cholos*, a term that came from California. In terms of young girls, sometimes they are called *chuquitas*, from the word *pachuquita*. In terms of adults, the word *cuerota* refers to a very sexy woman, while *guanga* means a fat, flab-

by lady. *Ruquito* refers to an elderly person; *jefitos* means parents. A married couple is one that's *enchanta'o*, meaning "to be at home." It comes from the word *chante*, a "house."

PADILLA: You also refer to a person in your poem as *el Colora'o*. What's that?

ARELLANO: That's a nickname meaning "redhead." *Colora'o* and *rojo* are "red."

PADILLA: What other words are used to refer to a car?

ARELLANO: Other words that are used for the automobile are *carrucha*, from the word "car," and *ranfla*, a word that came from the *Pachucos*, or the zoot-suiters, of the forties and fifties. Some real slow lowriders are referred to as *perrodos*, for a black insect that resembles a '64 Impala.

PADILLA: What are some other general terms that might be heard in an everyday lowrider conversation?

ARELLANO: When someone uses the expression *Chales*, it means to be quiet. *Tirando chancla* and *bolete* are both slang words for dancing. A *tecato* is someone who is hooked on heroin. A *marijuano*, on the other hand, is someone who smokes pot. The words *gallazo*, *frajo*, and *toque* are all slang for a marijuana joint. So are *yesca* and *grifa*.

PADILLA: Tell me some more.

ARELLANO: You know, a lot of lowriders like to enjoy a beer in moderation. Slang for beer is *bironga*, which is also sometimes referred to as *un seis*, a "six-pack." When someone talks about a *peda*, it refers to getting drunk. *Tirilongo* also refers to being inebriated; *carmelito* is when one has had too much wine to drink. *Turilailo* is someone who is a few sandwiches short of a picnic.

PADILLA: I've often heard the word *feria*. Can you explain it?

ARELLANO: *Feria*, in the way that lowriders use it, means "money." But it can also be a "fair."

PADILLA: There are a lot of other words I've heard that almost sound like they are English but that are definitely Spanish. What's that about?

ARELLANO: There are a lot of English words that have become "Hispanicized." Like the word *wachando* comes from "to watch," and *brecas* is derived from the "brakes" of an automobile. When someone says *trimear la greña*, they are talking about a "trim," a "haircut." Some Spanish words follow the same basic thinking. For instance, a *leñero* is someone who goes to gather firewood; it is an extension of the word *leña*, Spanish for wood.

'73 Chevy Stepside
Owner Luis Garcia of Española. Mural by Randy Martinez.

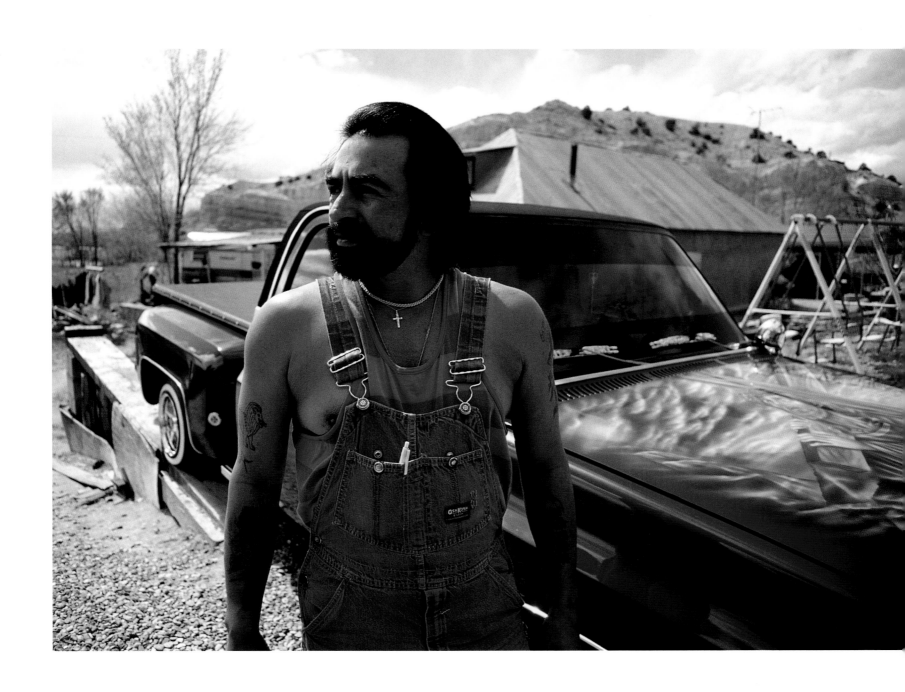

'75 Chevy Caprice
Owner Atanacio "Tiny" Romero of Chimayó

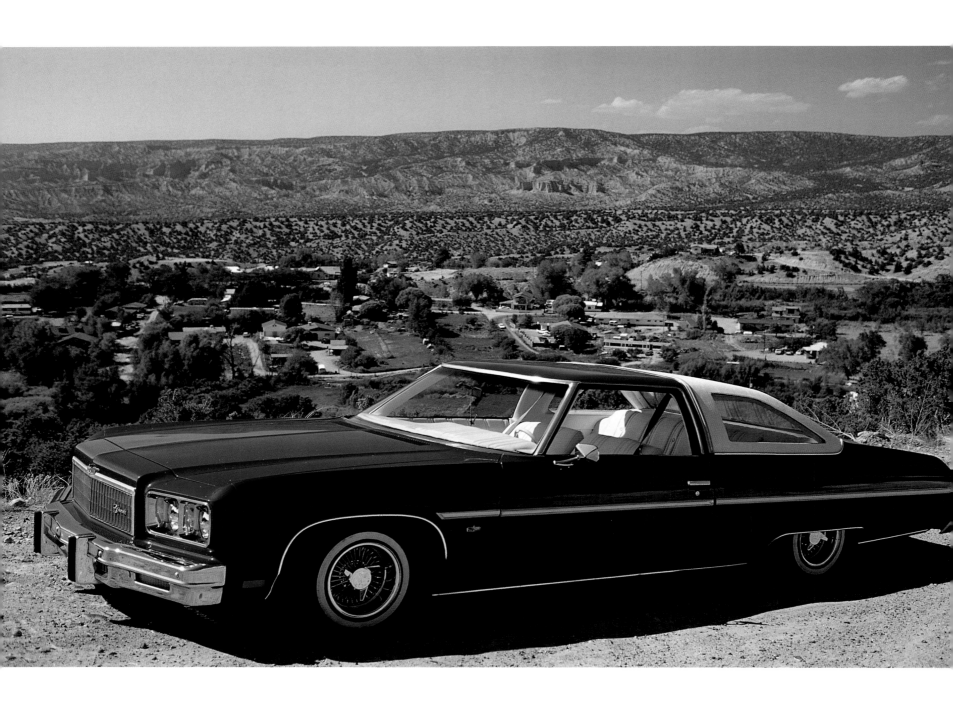

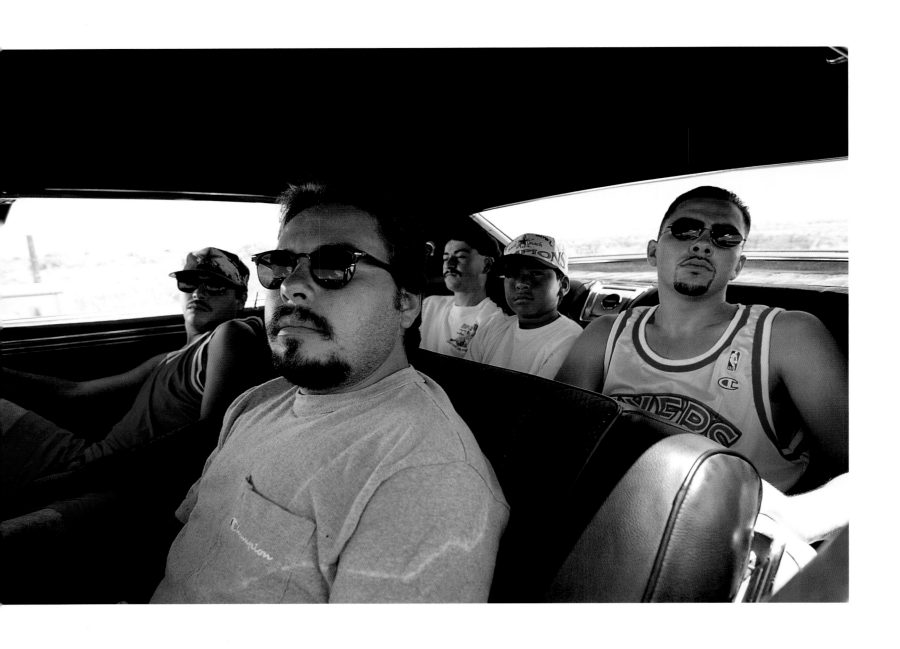

'66 Chevy Caprice
Owner Andreas Vigil of Fairview

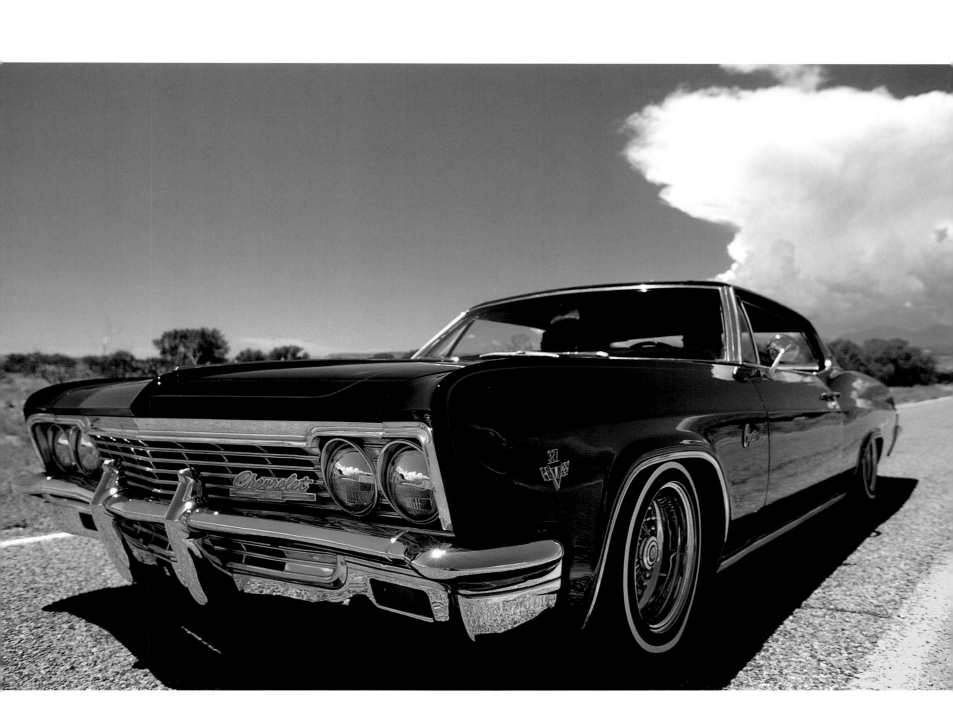

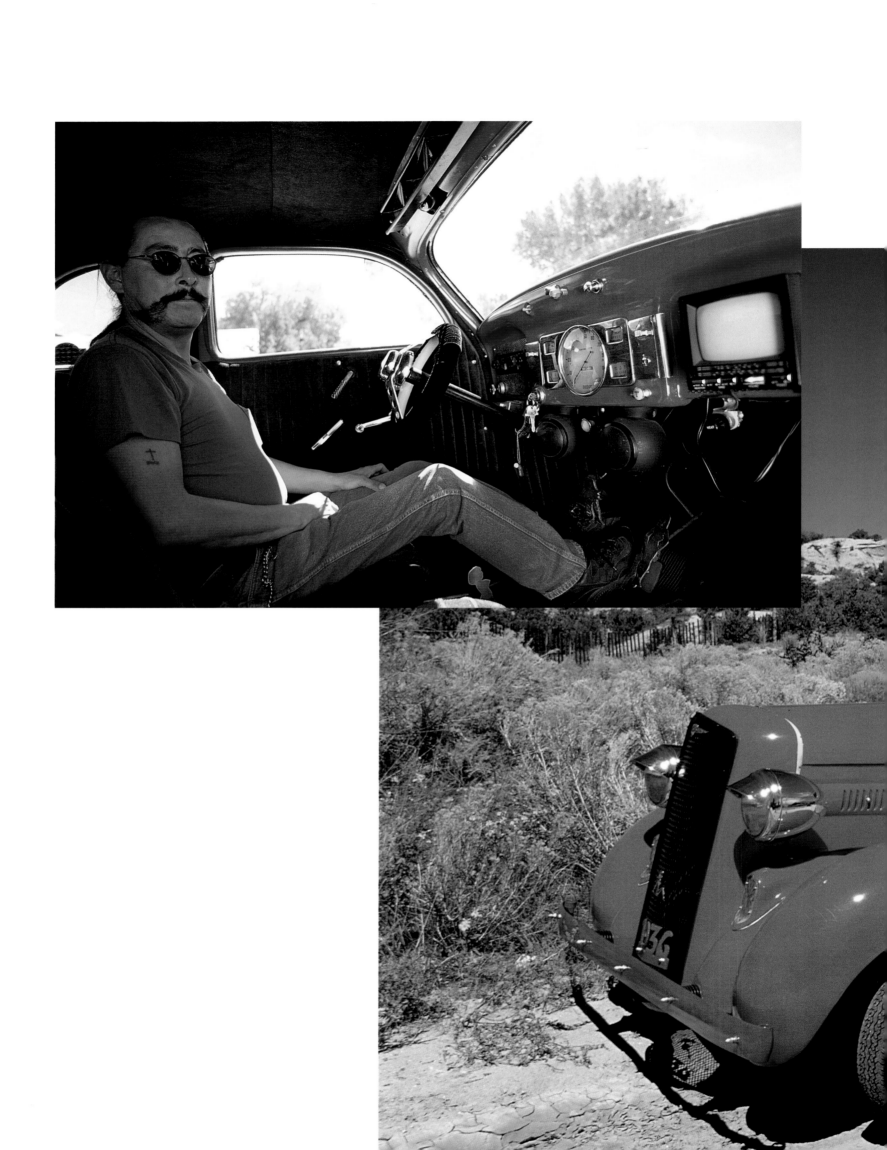

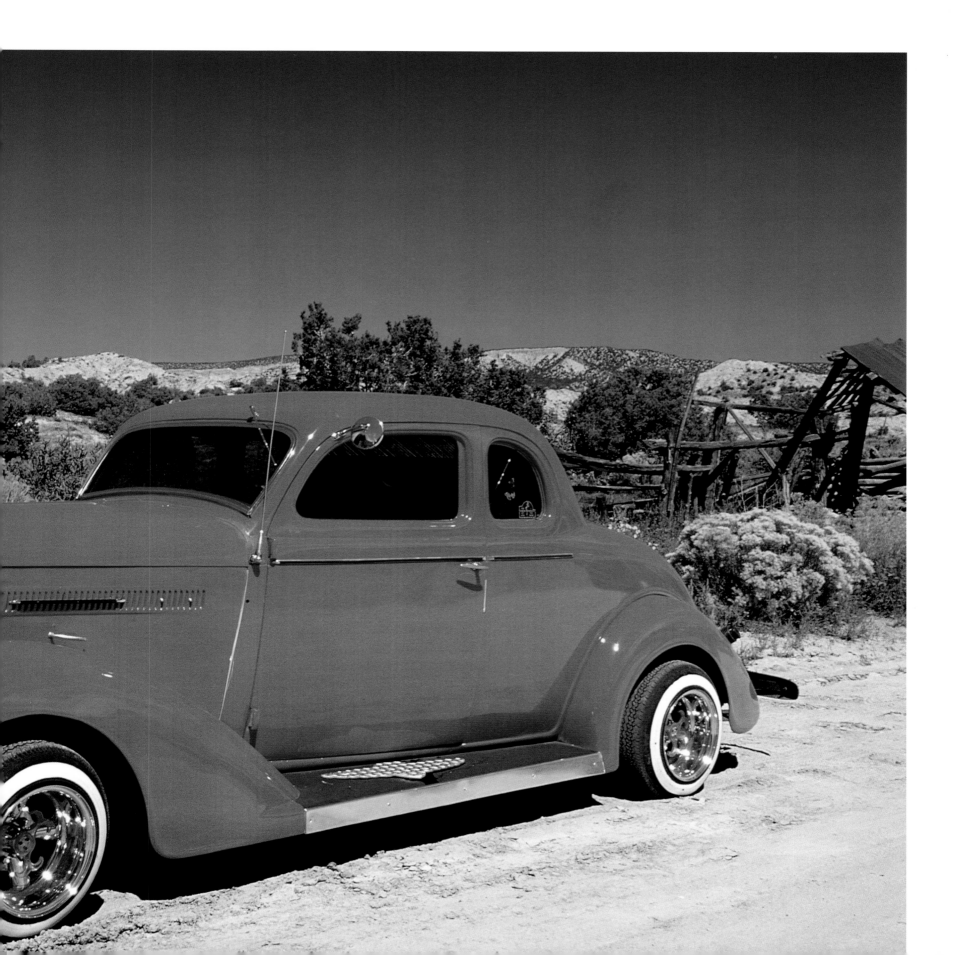

'36 Dodge Coupe
Owner Arturo Trujillo of Española

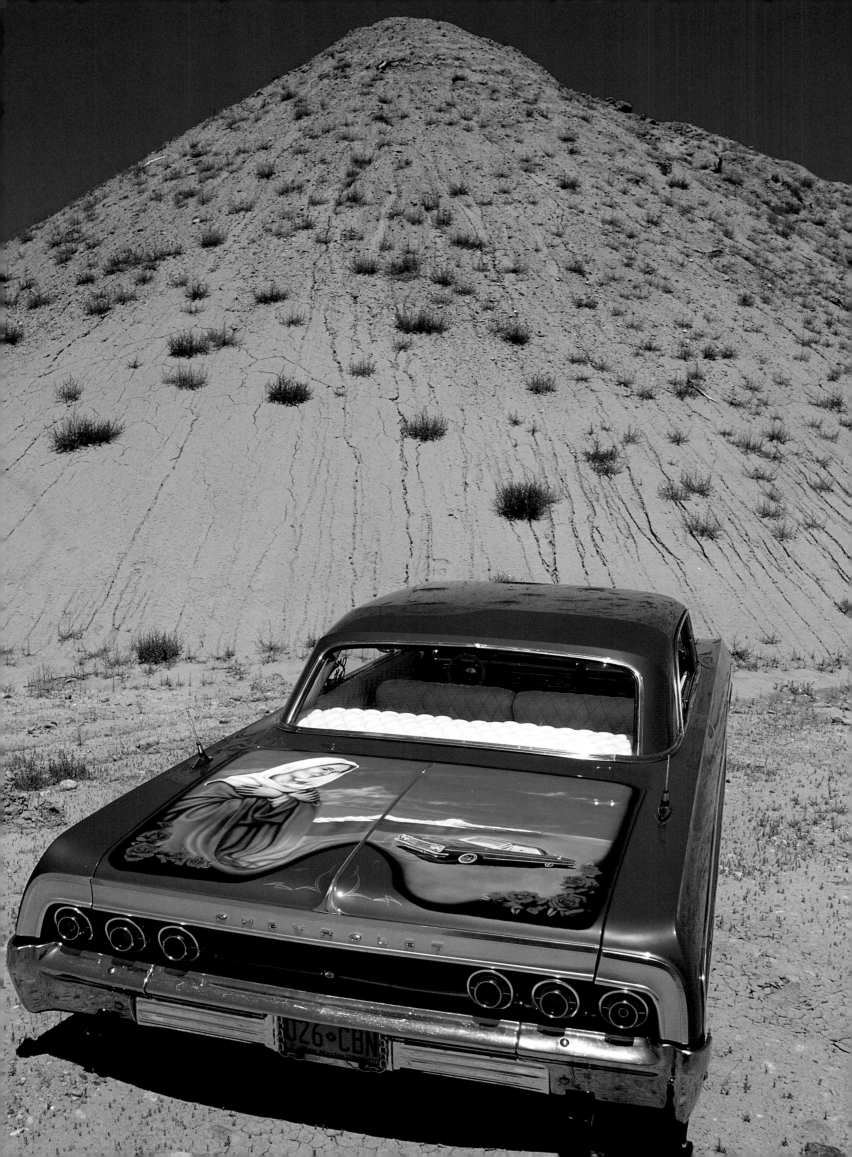

Dream Car

'64 Chevy Impala
Owner Eddie Gallegos
of El Llano

When Eddie Gallegos first brought his 1964 Chevrolet Impala home to El Llano, his wife, Barbara, dismissed the beat-up vehicle as junk. But after watching Gallegos restore the car from the inside out, his wife won't even let him drive it to the grocery store for fear that it will be hit.

"My wife was always telling me, 'When are you going to grow up?'" Gallegos says, "but even she likes the car now. She calls it her 'dream car.'"

Now, Gallegos has made the car the object of his eight-year-old son E. J.'s dreams as well. Ever since he was old enough to hand his father a wrench, E. J. has understood that if he stays out of trouble the car will one day be his. Gallegos also plans to buy another car to pass on to his nine-year-old daughter, Teresa.

"I tell my kids, 'I'd rather have you here fixing cars than out making trouble or fighting,'" Gallegos says. "They have to give me good grades and finish school. They have to be good and help me out here at the house. I remind them every day."

Gallegos, a former alcoholic, credits the car for keeping himself on a straight path in life. And his own example, he says, is the best life lesson he can give his children.

"To me, being a lowrider means being out of trouble," he says.

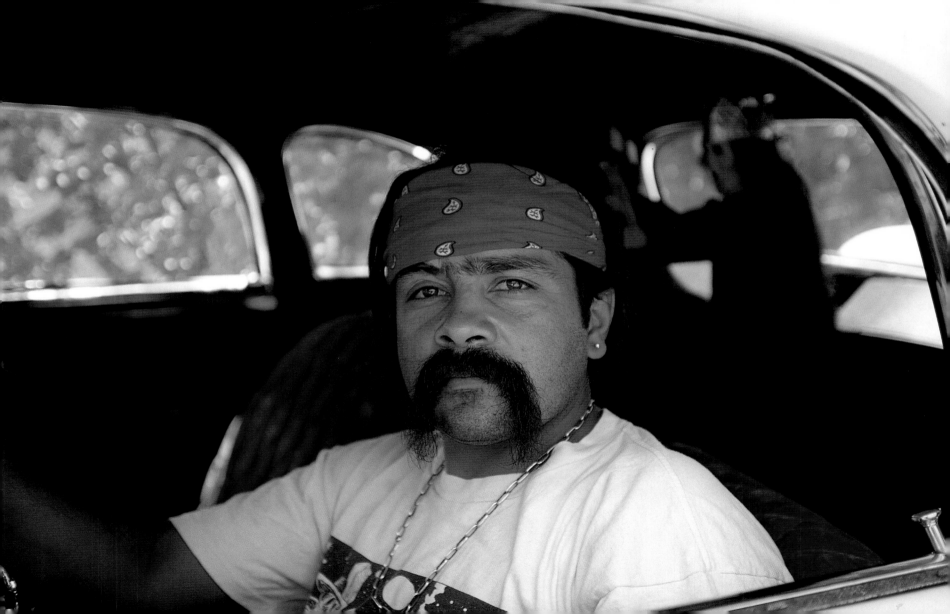

The body of the abandoned '39 Chevy sat in a dry arroyo bed in Ojo Caliente like an eggshell on the compost heap. Its exterior was pitted with bullet holes from all the times the locals had used it for target practice. The car had long been left for junk.

But as soon as Nicholas Herrera rescued it, it began the transformation to art. Herrera, a *santero* (a maker of religious images), saw sculpture in the weathered mountain of metal, and he hauled the dirt-filled hull to his El Rito home.

"I used five cans of WD-40 just to get the doors open," he recalls. "One guy bet me a thousand bucks I could never make it run."

Using a host of salvaged car parts, Herrera pieced the car together like a giant jigsaw puzzle. Mixed within his mobile hodgepodge were the front end of a Ford Mustang, the back end of a Camaro, a Barracuda steering column, and a 327 engine from a '67 Corvette. Herrera painted the car pearl white, and a friend adorned it with images of some of Herrera's favorite saints. Five years and more than $20,000 later, the resurrection was complete.

"That guy who bet me, I cruised up to his house one day just to see the look on his face," Herrera says. "If you want a bad-ass lowrider, you build it from scratch."

'39 Chevy Coupe
Owner Nicholas Herrera
of El Rito. Artwork by
Desi Lopez.

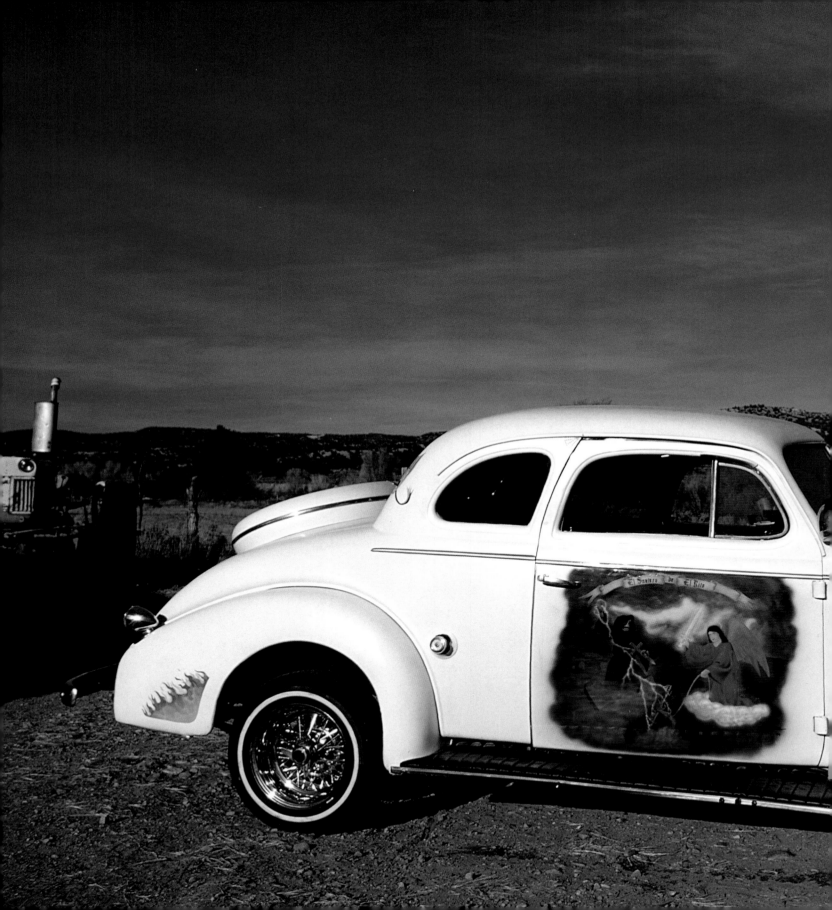

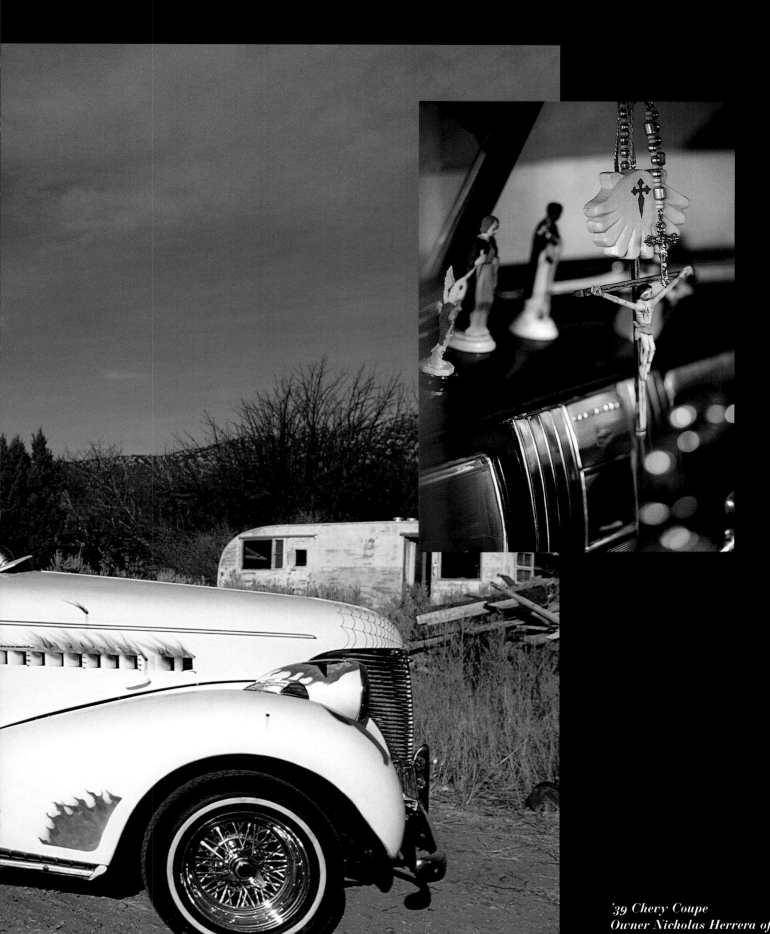

*'39 Chevy Coupe
Owner Nicholas Herrera of El Rito.
Artwork by Desi Lopez.*

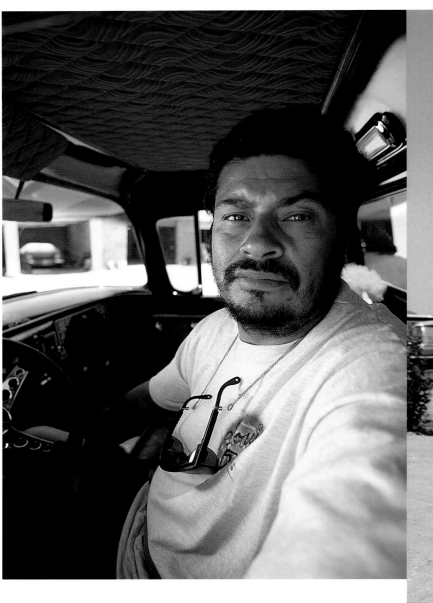

'56 Chevy pickup
Owner Louis Martinez of
Hernandez

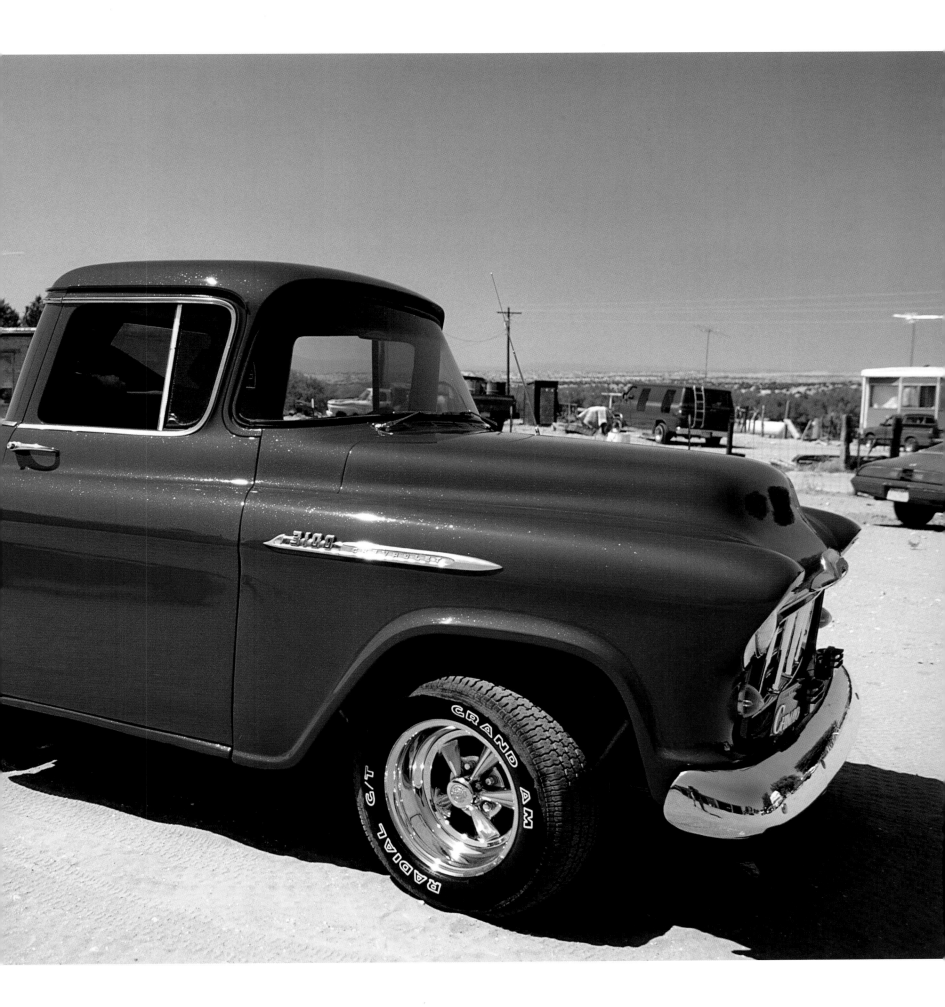

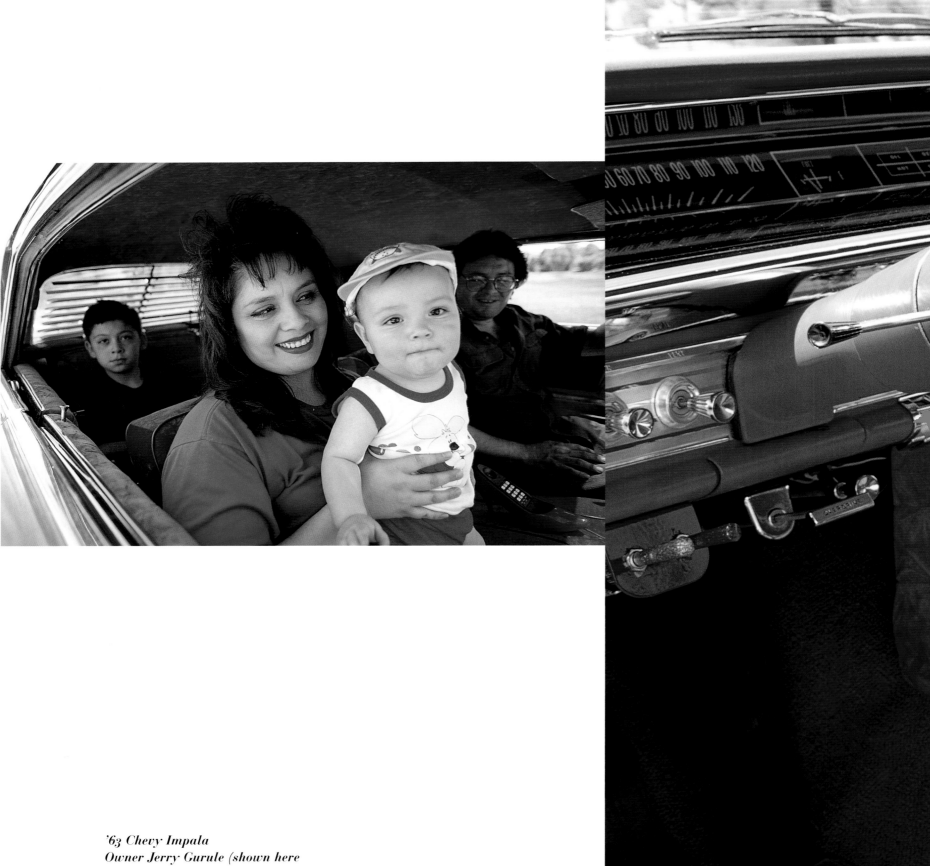

'63 Chevy Impala
Owner Jerry Gurule (shown here
with family) of Peñasco

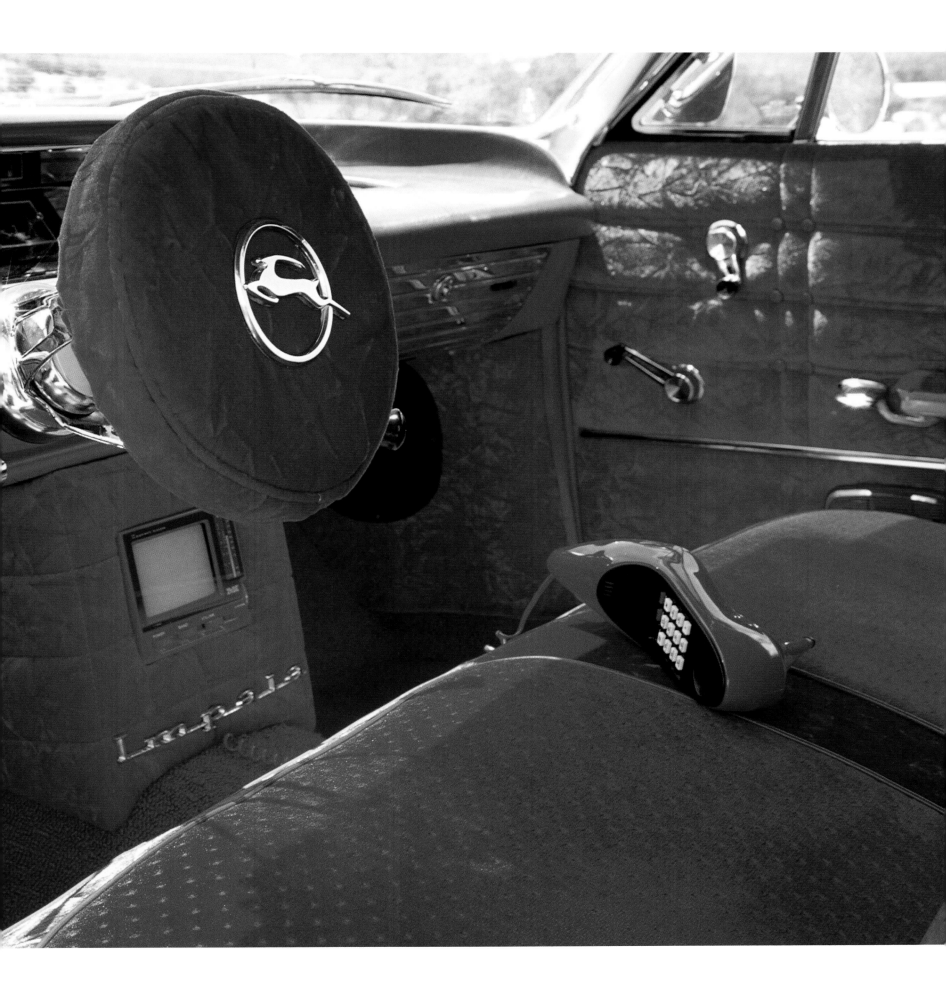

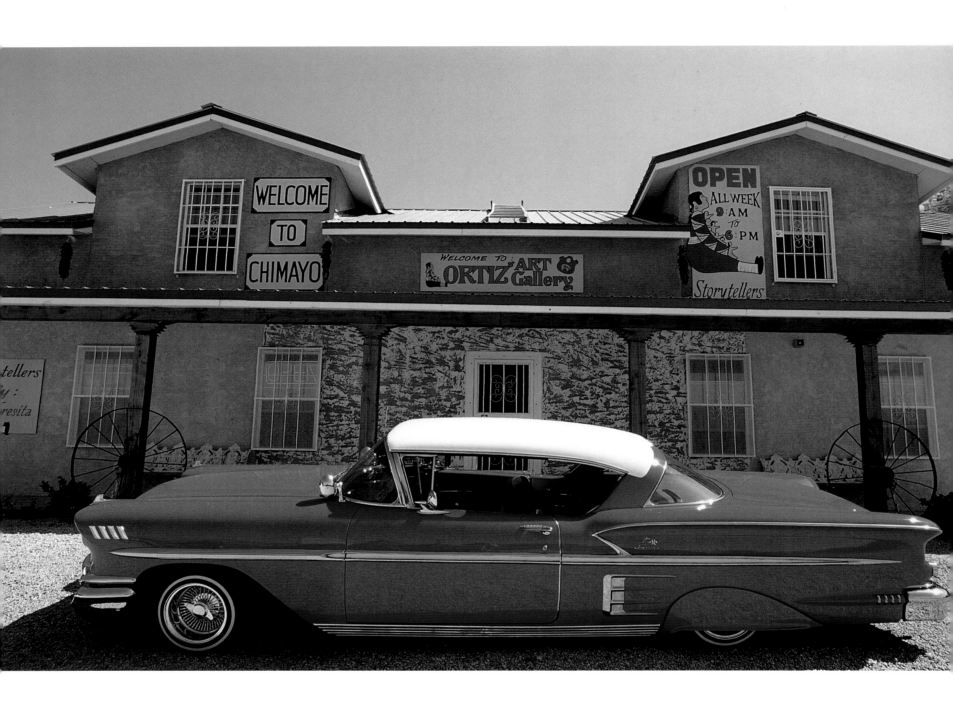

'58 Chevy Impala hardtop
Owner Wray Ortiz, Jr., of Chimayó

'58 Chevy Impala hardtop
Owner Wray Ortiz, Jr.,
of Chimayó

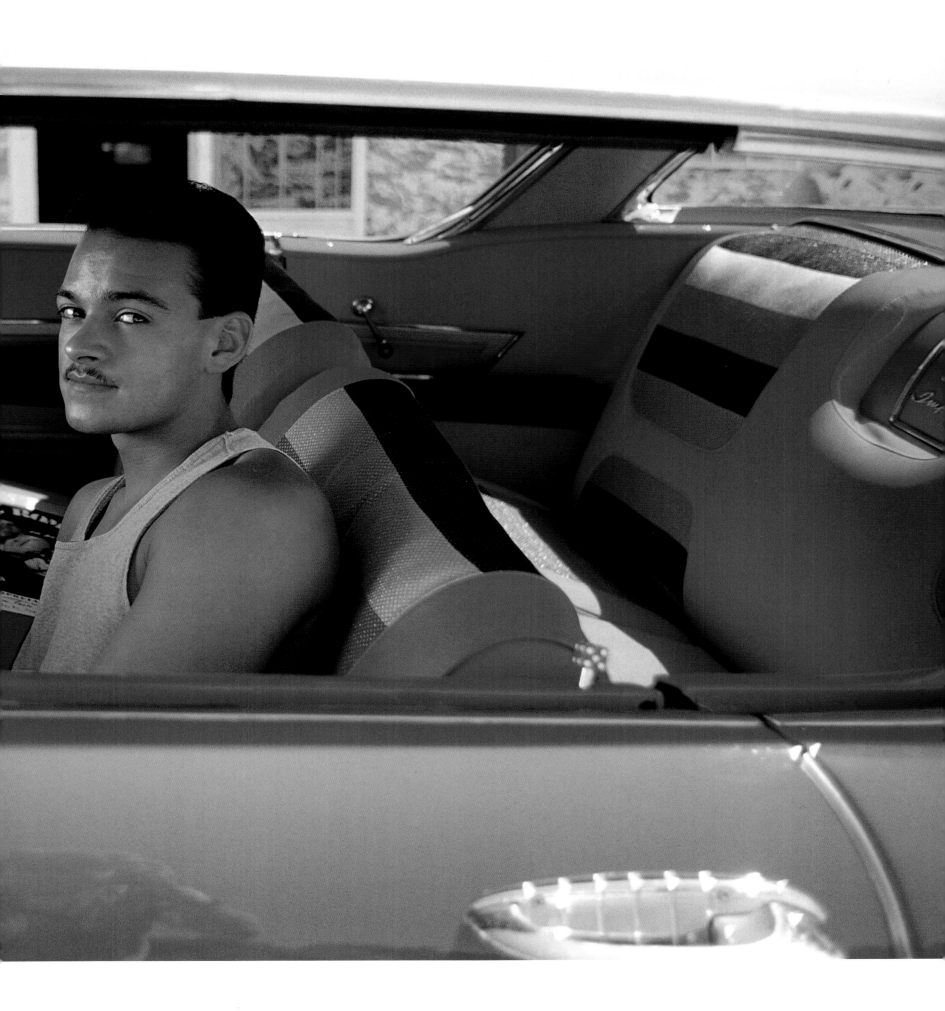

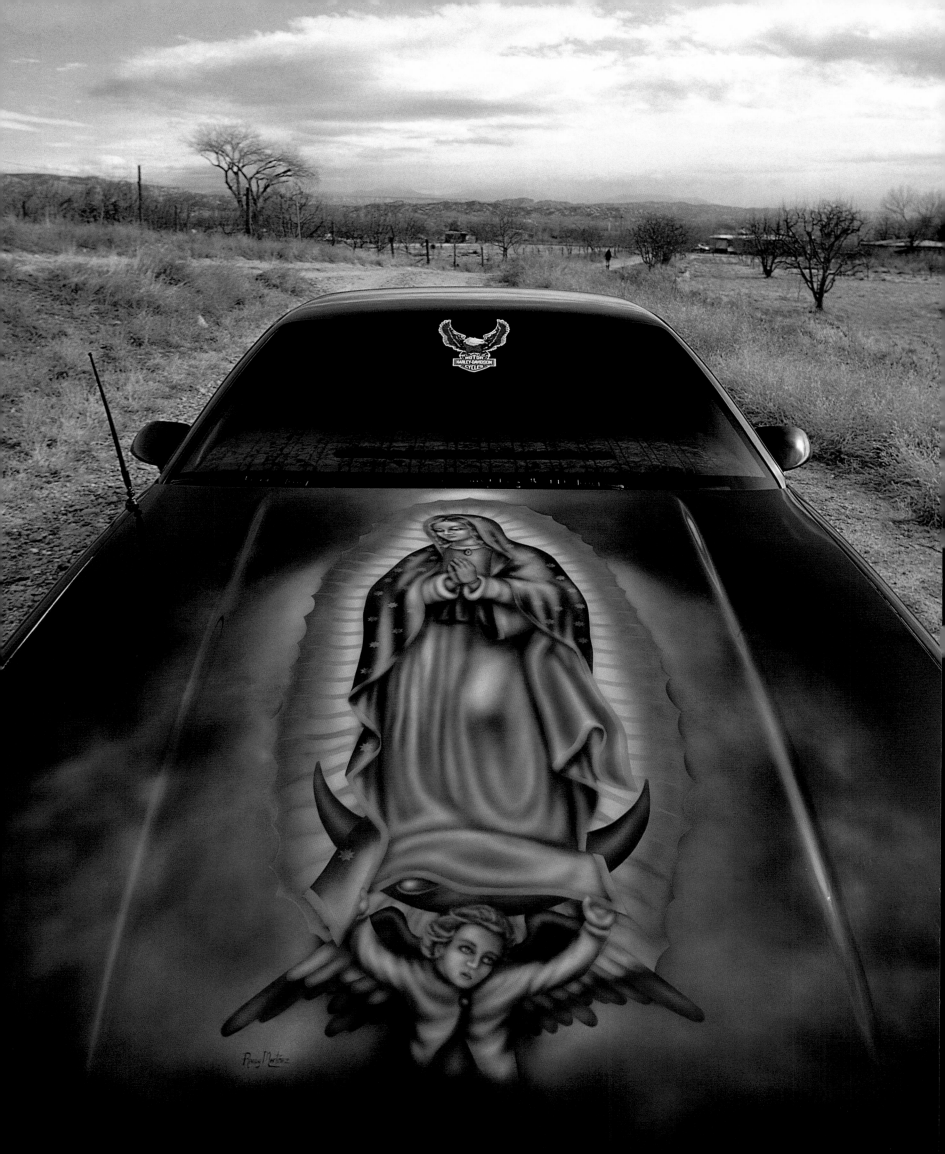

Four-Wheel Faith

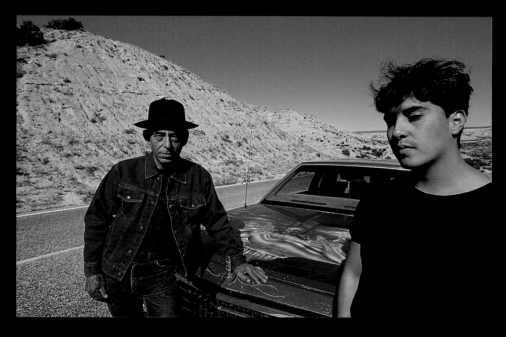

'79 Ford LTD
Owner Leroy Martinez
of Chimayó. Mural by
Randy Martinez.

left
'84 Chevy Camaro
Owner José Velarde of Velarde.
Mural by Randy Martinez.

In the gray dawn of morning, on a cloudy Sunday after a night of rain, a parade of cars cruises into the center of Chimayó. Giant puddles of water and mud fill the parking lot of the Santuario de Chimayó. The drivers swerve to avoid the muck as they park in front of the church.

One by one, as their engines fall silent, they gather around their distinctive driving machines. Our Lady of Guadalupe glistens on the dark blue hood of José Velarde's 1984 Camaro while Christ's Resurrection and Ascension are played out in brilliant blue-green hues on Norman Sanchez's '73 Monte Carlo. Leroy Montoya's 1990 Nissan pickup features Jesus in a flowing robe, and Victor Martinez's '79 Cadillac broadcasts a panoramic view of Chimayó with its legendary santuario painted alongside other village landmarks.

The men have come to Chimayó this morning from Peñasco, Española, and points north to worship at the chrome altar of a new Chimayó religion. Randy Martinez, the self-taught Chimayó artist who painted the cars, is the acknowledged master of that religion's new art form. Using the automobile as his canvas, Martinez paints devotional

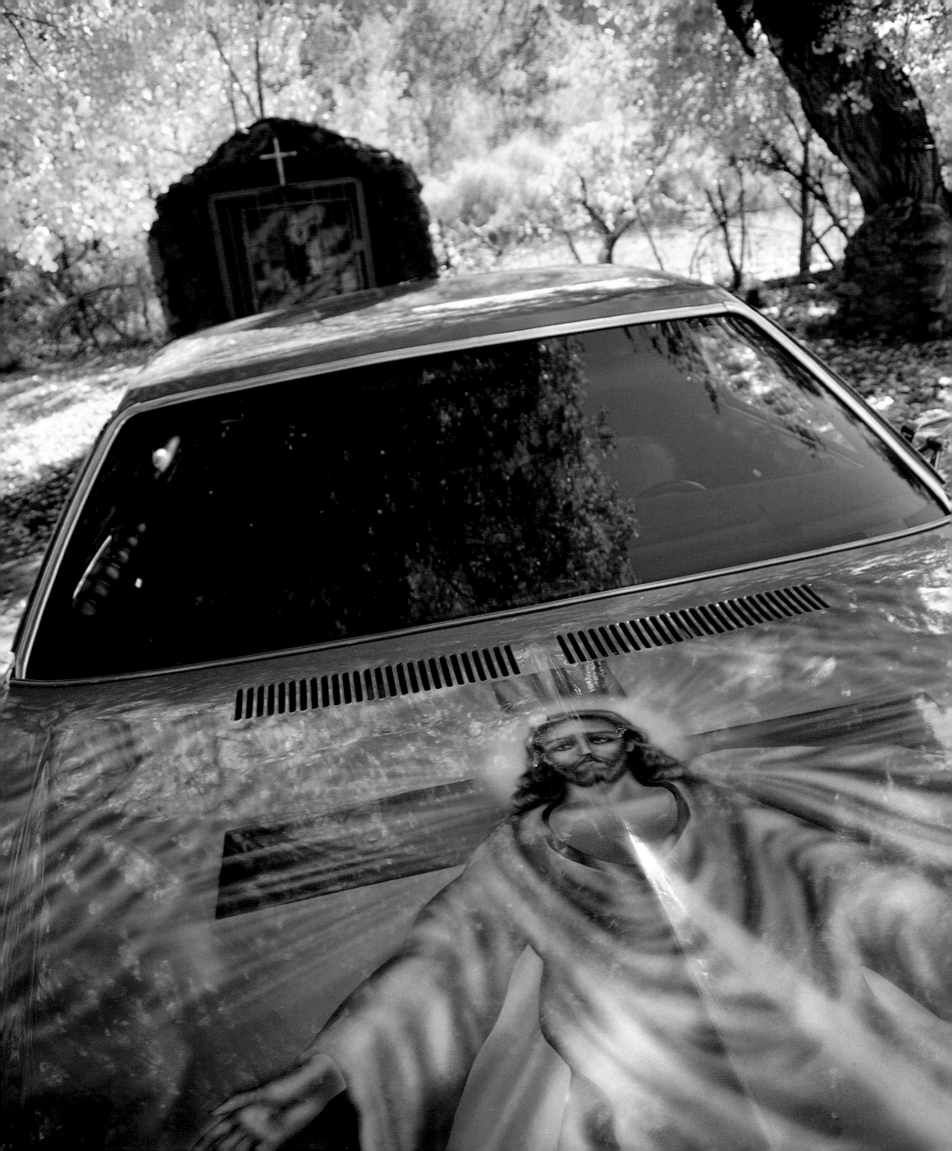

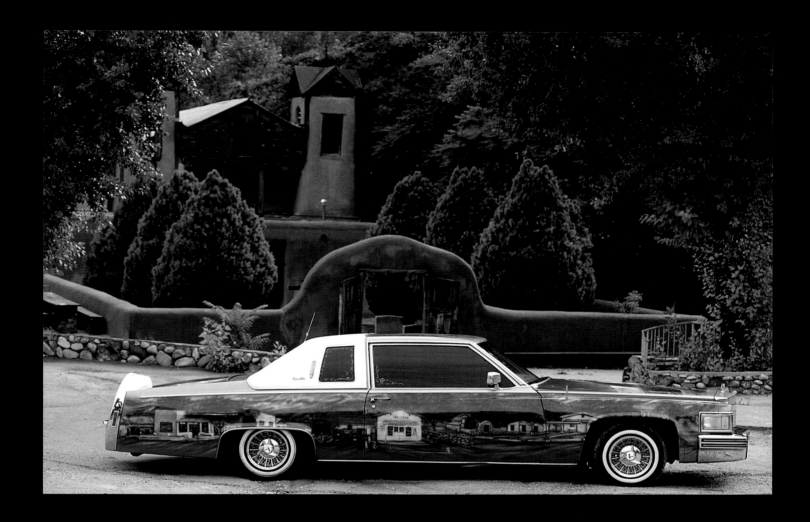

'79 Cadillac
Owner Victor Martinez of Chimayó.
Murals by Randy Martinez.

left
'73 Chevy Monte Carlo
Owner Norman Sanchez
of Española.
Mural by Randy Martinez.

images usually reserved for church and home onto car hoods, trunks, rooftops, wheel covers, and other exteriors. His luminous and detailed works merge the region's traditional religious iconography with contemporary car culture. In his hands, ordinary cars become grand objects of faith to idolize and to drive. "Cars," Martinez says, "are an extra way of communicating without the words."

During the warm months, Victor Martinez often parks his Cadillac just outside the santuario, where it has become as much a local landmark as the church itself. "I could have already built a good house with that car," Martinez says, referring to the thousands of dollars he has spent on his creation. "But in this town, what you drive is more important than where you sleep."

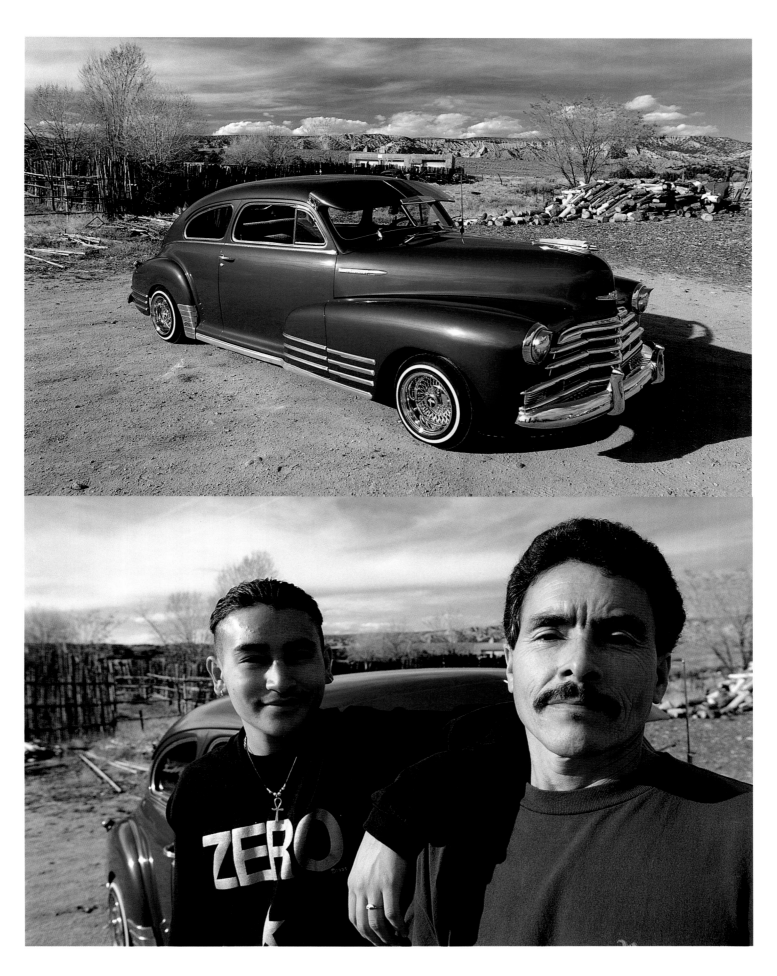

'47 Chevy Fleetline
Owner Joseph Romero
(shown here with son) of Chimayó

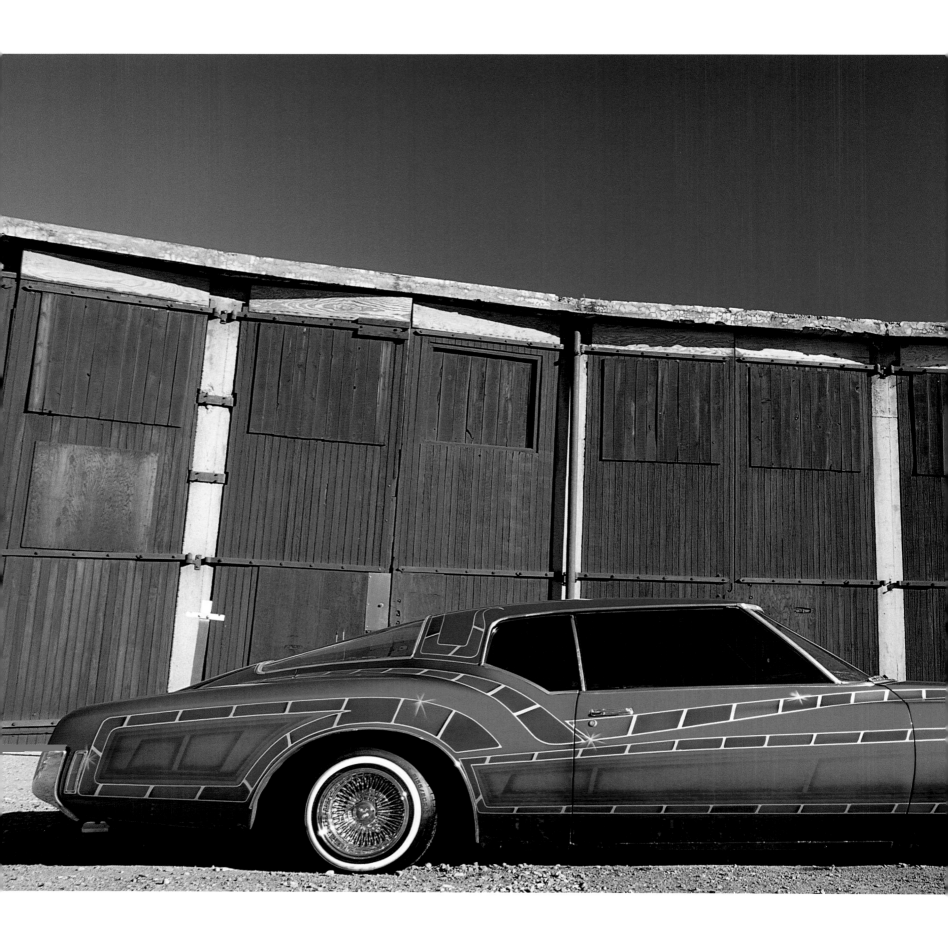

'72 Buick Riviera
Owner Adam Garcia of Las Vegas, New Mexico

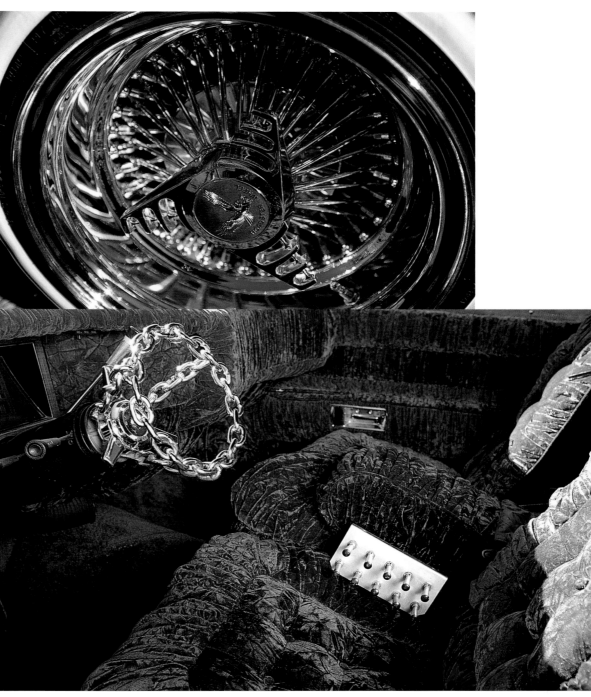

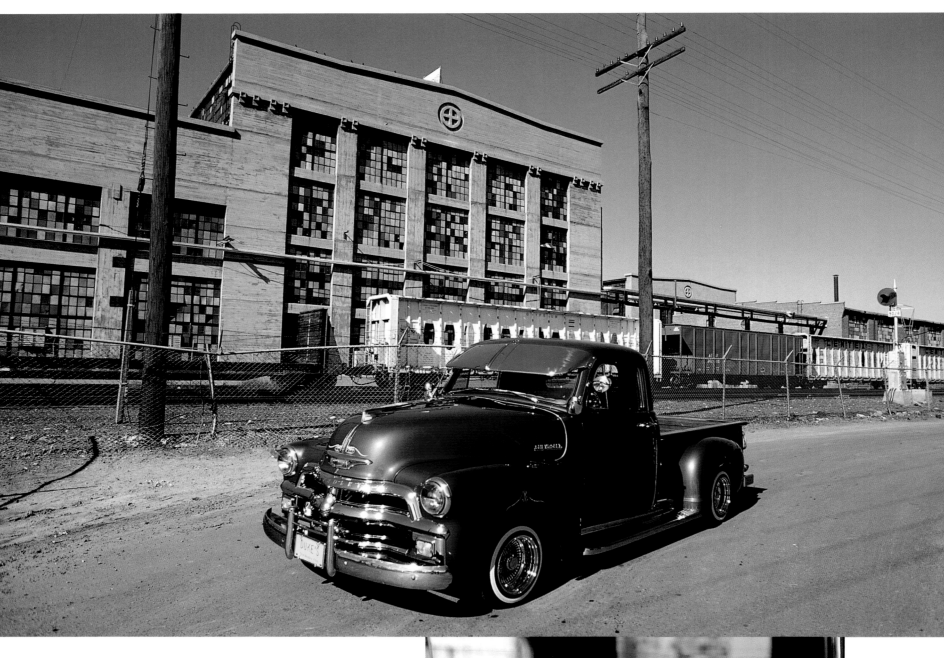

'41 Chevy pickup
Owner Frank Chavez of Albuquerque

right
'91 Plymouth Colt
Owner Eddie Tafoya of Española

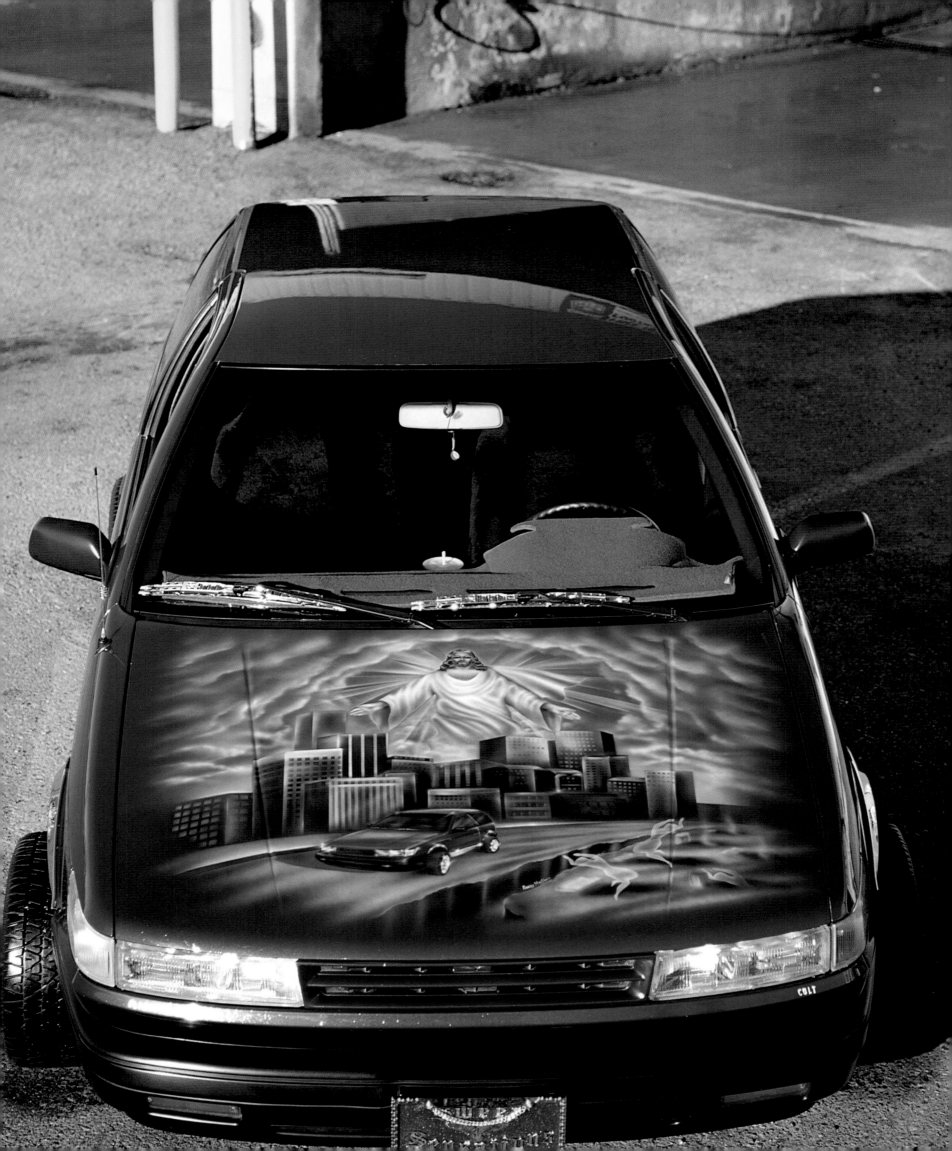

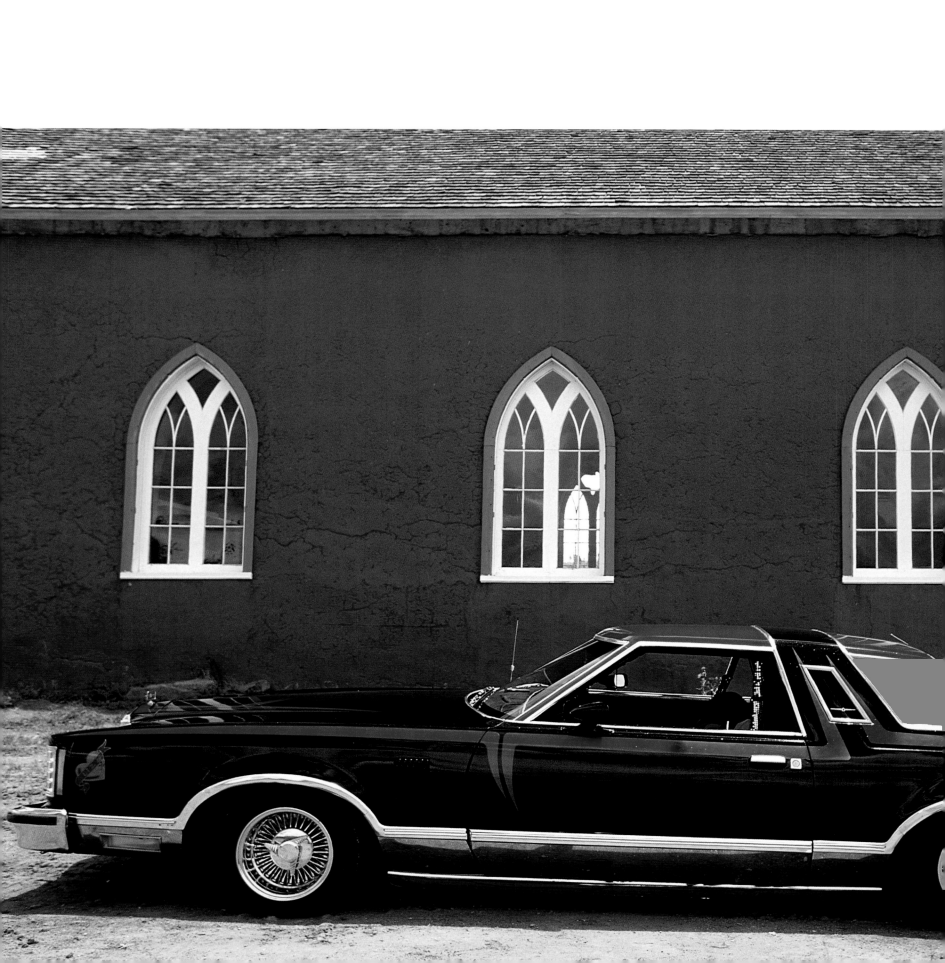

'78 Ford Thunderbird
Owner David Maes of Cleveland, New Mexico.
Mural by Freddy Olivas.

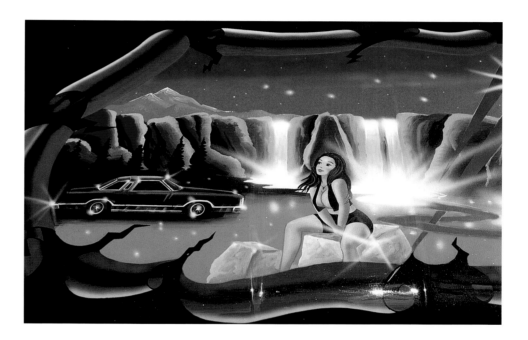

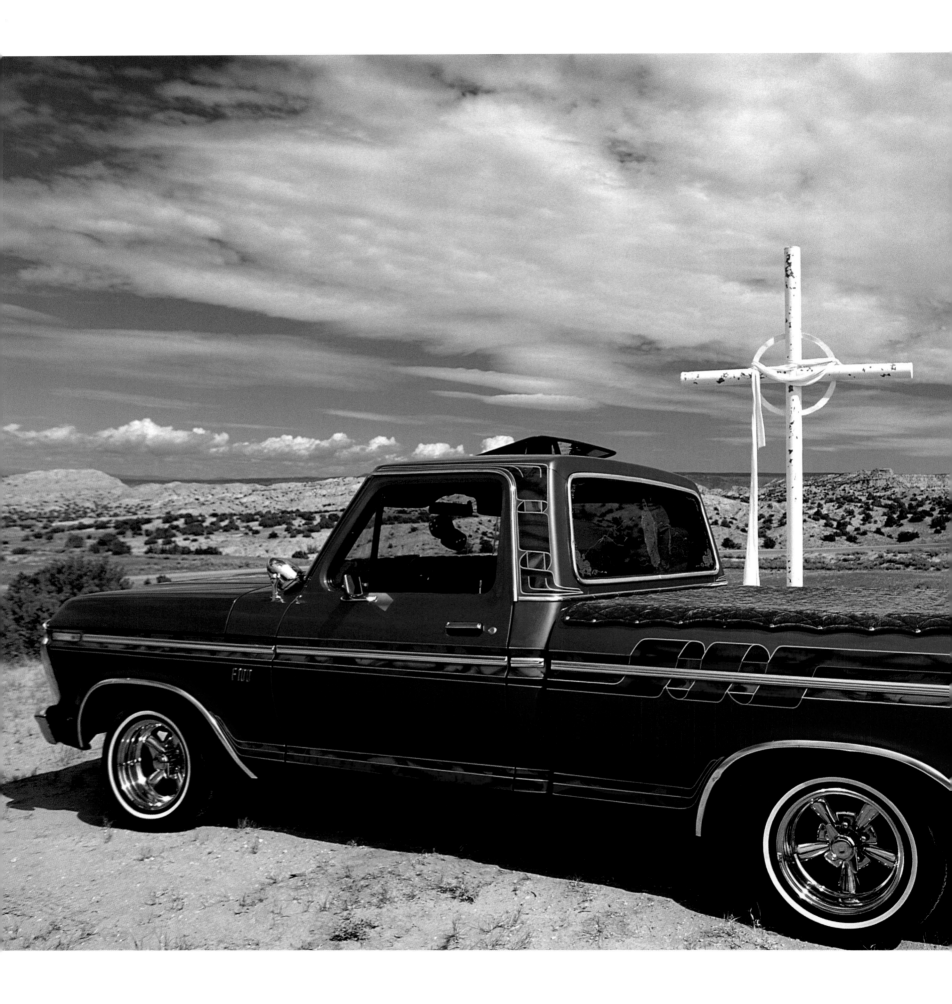

'73 Ford pickup
Owner Dennis "Chicago" Chavez
of Chimayó

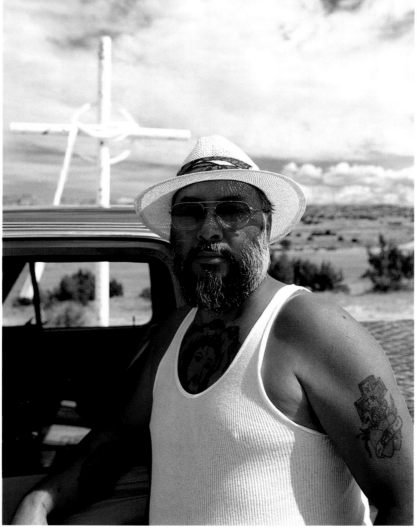

La Virgen de Guadalupe Crusing down Chimayó

by Juan Estevan Arellano

La Virgen for years has been floating above the *Río Grande*, where the *Río Fernández* joins the cold waters of the north on their journey south to Brownsville, *el Bravo del Norte se vuelve el Río de las Palmas.*

Like a sentry overlooking its flock below, the *Virgen del Pilar* watches over her people going *a la leña en* Carson, *en sus* pickups *viejitas,* and once in a while an old lowrider sputters down the gravel road.

Who etched *La Virgen del Pilar* on the huge basalt rocks of the mighty *Río del Norte* no one knows, *"nomás Dios sabe," decía mi mamá*; but like the Mexican ballad echos, *"solamente la mano de Dios,"* the hand of the almighty was what carved the *virgen* on the stone, and it used the softest of tools to do the work, *agua bendita,* for it was the water from a nearby *arroyito,* as it traverses the *llano* on its way to the river, over time sculpted *la virgen de los lowriders* on the west side of the gorge.

This is where all the *leñeros,* and now the lowriders, stop to gaze at the *virgen,* finish off a six-pack, roll a *gallazo, tirar el chorro,* and discuss metaphysics and philosophy, *de dónde, y quién hizo esa Virgen,* that everybody says has been there for eternity; *"mi abuelito y mi bisabuelo platicaban que sus bisabuelos se acordaban de la Virgen de la Cieneguilla,"* according to the philosophers of *la resolana.*

The old-timers would always refer to *Pilar* as *"la Cieneguilla,"* since the town today famous for rafters, when it got a post office, became *Pilar* in honor of the wife of the postmaster.

La Virgen Morena, la Señora de Tepeyac, it's still recognized by all as *La Virgen de Guadalupe, "la Upe,"* as some call her jokingly, *pero cuando se les atora un chasco,* that they have to pray to someone, it's always to *"La Virgen de Guadalupe," que todos aclaman.*

The *viejitas* with their *tápalos* and their icon of *"la virgen"* held tightly in their shriveled hands, the *cholos* with their tattoos all over their backs, some awesome works of art on skin, others so-and-so, but none compare to the master works of art of *"La Virgen de Guadalupe"* on the hood, or trunk, of the lowriders descending from the various villages—*hechos línea como hormigas*—as they march towards Española and the annual lowrider car show.

There's *Pedrito,* also known as "Pete," or "Peter"; he's from Chimayó, from *"el Arroyo del Medio,"* that for a long time he wasn't able to drive his *ranfla, su carrucha aplanada,* to his house because of his car being so low and slow—many a night his '74 Monte Carlo had to spend the night alone at his *camarada's* near Highway 75.

Every night he would pray to *"la Virgen," a la Señora de Tepeyac, a la Virgen Morena,* to take care of his priceless car, the one with the most beautiful painting of *"la Virgen,"* done by the famous painter from *Córdova,* the one who had only done *bultos of "la Virgen." Siempre rezándole a la Virgen Morena.*

To his surprise, *"la Virgen"* that he painted on the *"Monte"* turned out to be a masterpiece; everyone who has seen it can't believe their eyes, that an uneducated *santero "de los chicos"* had painted the best portrayal of *"Upe"* that anyone had seen. It was incredible, the colors superb, the draftsmanship out of this world.

Another Don Diego, uneducated, *pero con fé; "no hay nadie que tenga más fé que Fulano de tal,"* the people from *Córdova* had been saying for years, for eternity it seems like, now everyone knows about his hidden talent. Always praying to *"la Virgen."*

She who was born from *maíz,* from the south, unlike Moctezuma who was born from a *piñón,* making him a *norteño. Nuestra señora de Tepeyac* never imagined herself cruising from Sonic to Sonic in Española with a bunch of *cholitos* and a couple of *chuquitas* from Río Chiquito.

Never would the *virgen* have imagined herself venerated by the *"vatos locos"* from the north, appearing in murals, paintings, poetry, or in a *bulto* form, from studio tours to the Spanish Colonial Market, and even on *pinto* art, *en los paños,* that is, handerchiefs.

Virgen Morena, virgencita querida, siempre en nuestros apuros y afanes nos acordamos de ti, it's only in our tribulations that we remember you, it seems, but you are always in our thoughts and prayers, "Brown Mother" of the Americas, mother of the *mestizo,* the *chuco,* the *cholo,* the *hispano, latino, chicano, nuevomexicano, manito, paisano, mulato.*

Whether riding on the back seat of a Monte Carlo, adorning the trunk of a '64 Chevy, on the back of a *rato loco o pinto*, wherever you are, *Virgen Morena*, protect us and guide us, same as when we are on *la peda, o poco tirilongo* that you intervene for us and drive us home safe.

Only *hispanos, chicanos, la raza plebe,* can be cruising and hopping, bouncing like a jumping bean, drinking and driving while praying to *"la virgencita, por favor que no me tuerza la jura,"* as the sheriff zooms in the opposite direction with its siren on as he finishes with the sign of the cross.

"Virgen Morena, perdóname," forgive me *Virgencita de Guadalupe*, but I promise you that on Dec. 12, for your birthday, we'll throw a big party. Everyone will be there, Johnny, *la* Janet, *la* Joyce, *el Chuey, la Presiliana, Juan de la Cruz.*

Virgencita, you who have cruised in more lowriders than anyone, you who have appeared mysteriously on more bare backs than a *vaquero* has mounted *mesteños,* don't ever forget your people because *la raza* will never forget or abandon you; if not stoically keeping guard over an *abuelita's altar* you are partying with *la plebe* at the Double-L.

Virgen querida, tú eres de la gente y la gente es de ti. Amén.

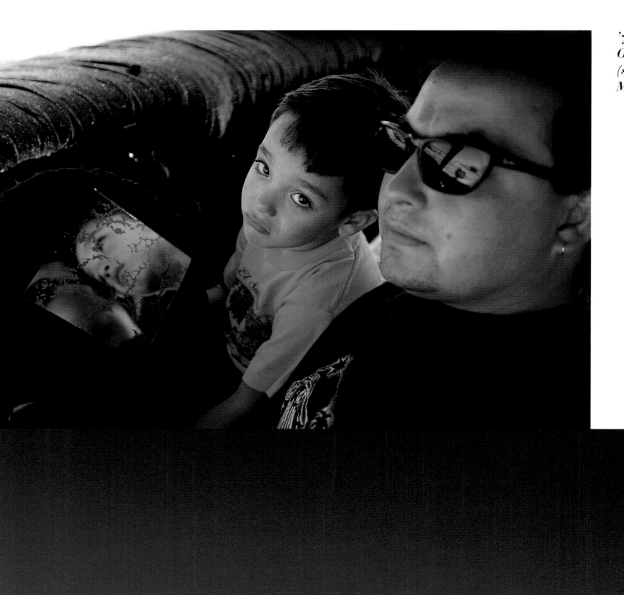

'78 Ford Thunderbird
Owner Chris Martinez
(shown here with son) of Chimayó.
Mural by Randy Martinez.

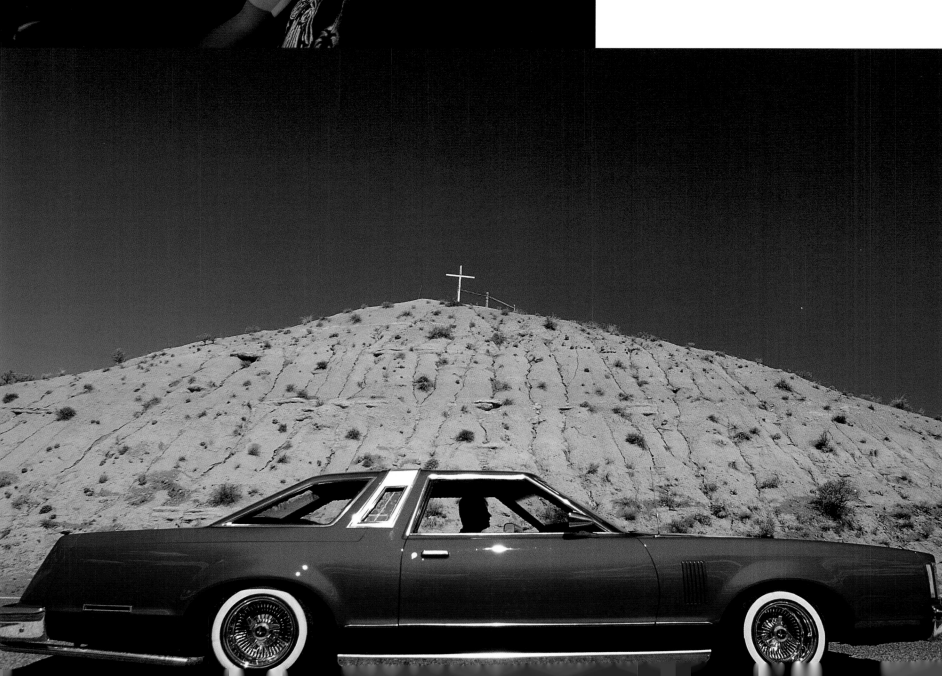

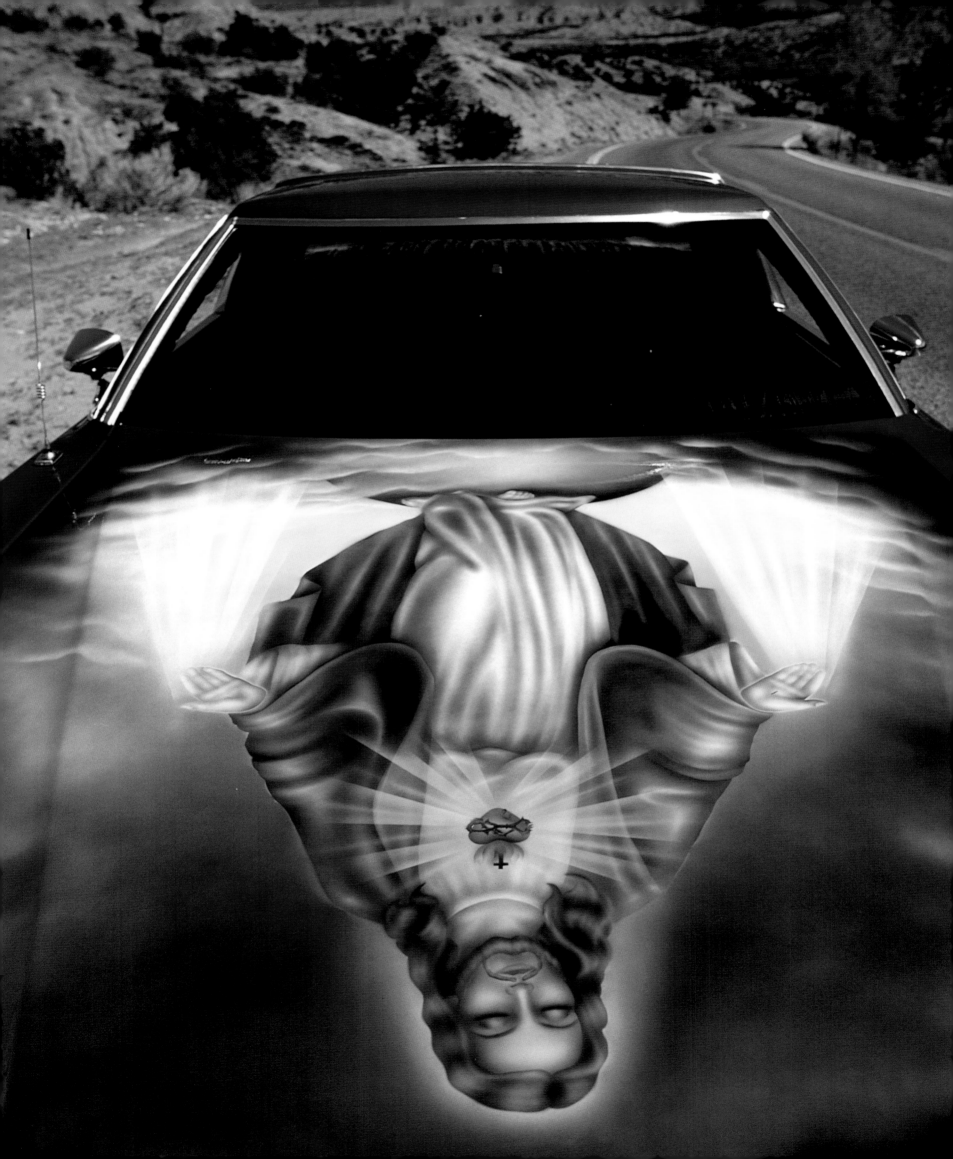

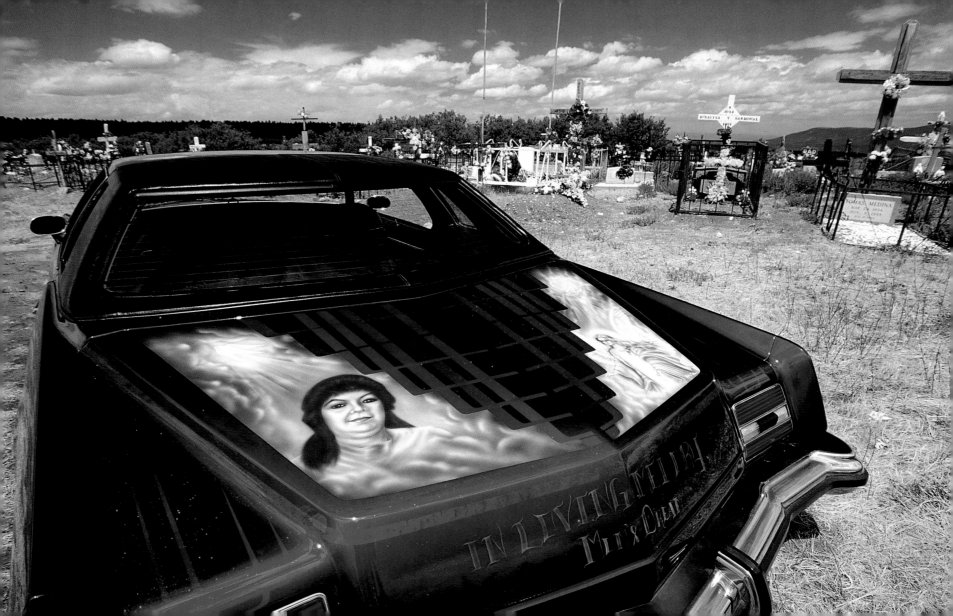

Rest in Peace

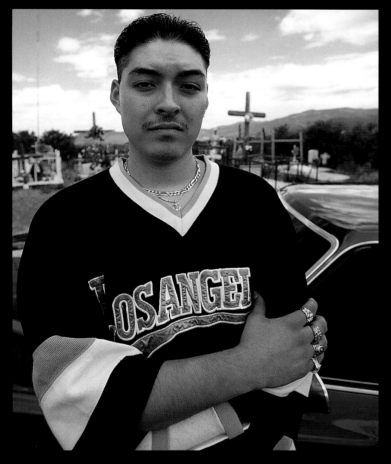

'73 Pontiac Grand Prix
Owner Eloy Sandoval
of Peñasco

It was the 26th day of January in Chimayó, 1991, the day thirteen-year-old Eloy Sandoval's world was frozen in a storm of gunfire.

"It was my mom's ex-boyfriend," Sandoval recalls. "She was moving her stuff out of their trailer. He showed up with all kinds of guns and started shooting everybody." Dead were Sandoval's mother, Ignacita, his two sisters, a nephew, brother-in-law, and two policemen. Eloy Sandoval took a bullet in the chest. The media dubbed the event "the Chimayó Massacre," the worst mass murder in New Mexico history.

Eloy went to Peñasco to live with his father. About the only things he had left of his mother were the painful flashbacks of her murder and her 1973 Grand Prix. "She had always wanted a nice paint job and nice wheels. I always wanted a lowrider," he says. "I decided to fix up the car in memory of my mom. Whenever I worked on it, I felt peace."

Today, the car is candy organic green with a cloud-shrouded portrait of Ignacita Sandoval painted on its trunk and the words "In Loving Memory: Mom's Dream." Sandoval has his own dreams for the car. "I'm not going to stop working on it," he says, "until it's the centerfold of *Lowrider* magazine."

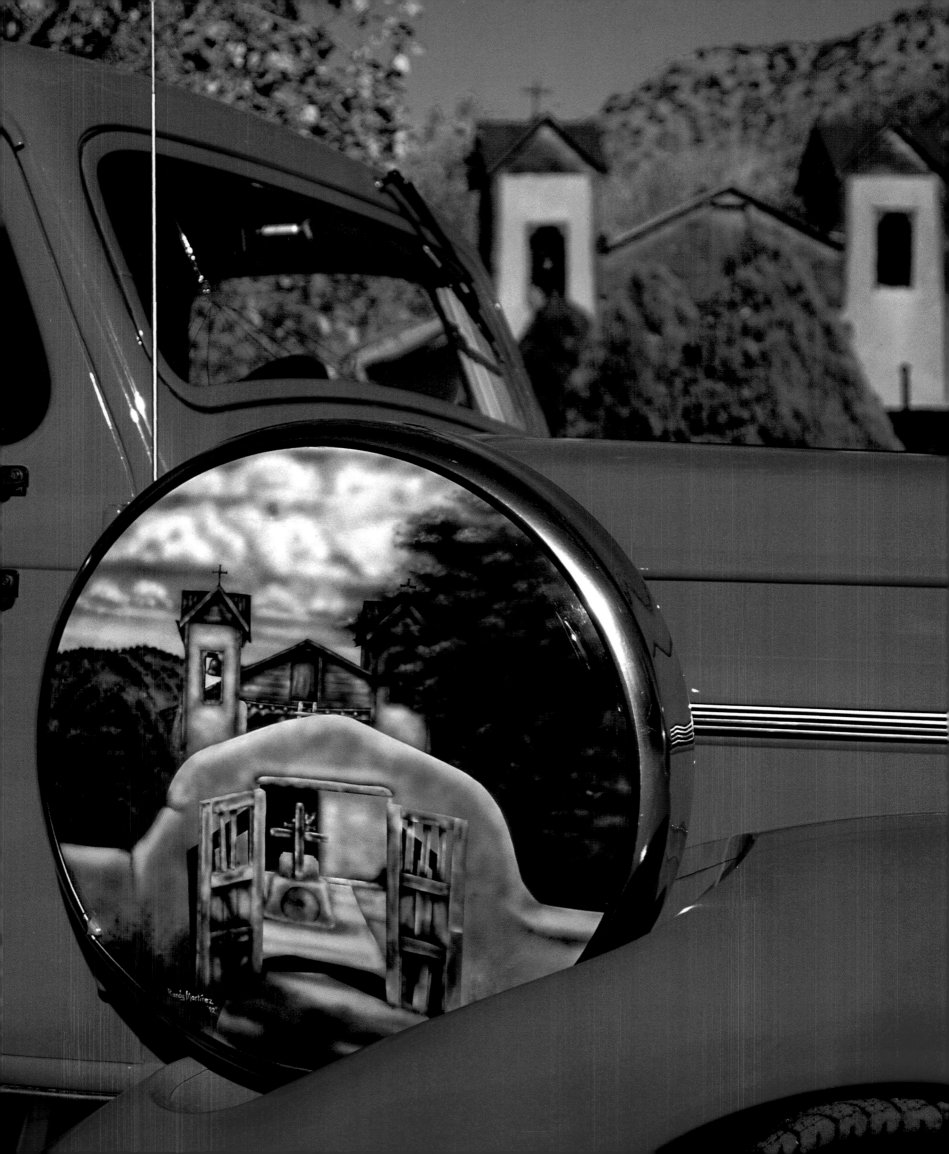

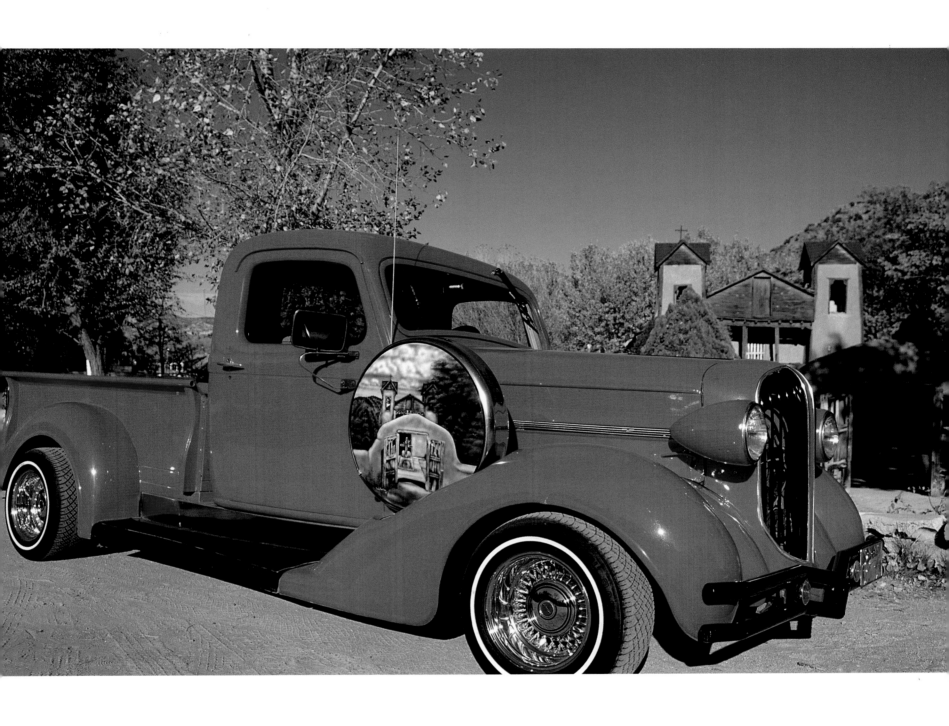

'37 Plymouth pickup
Owner Willie Sanchez of Chimayó.
Artwork by Randy Martinez.

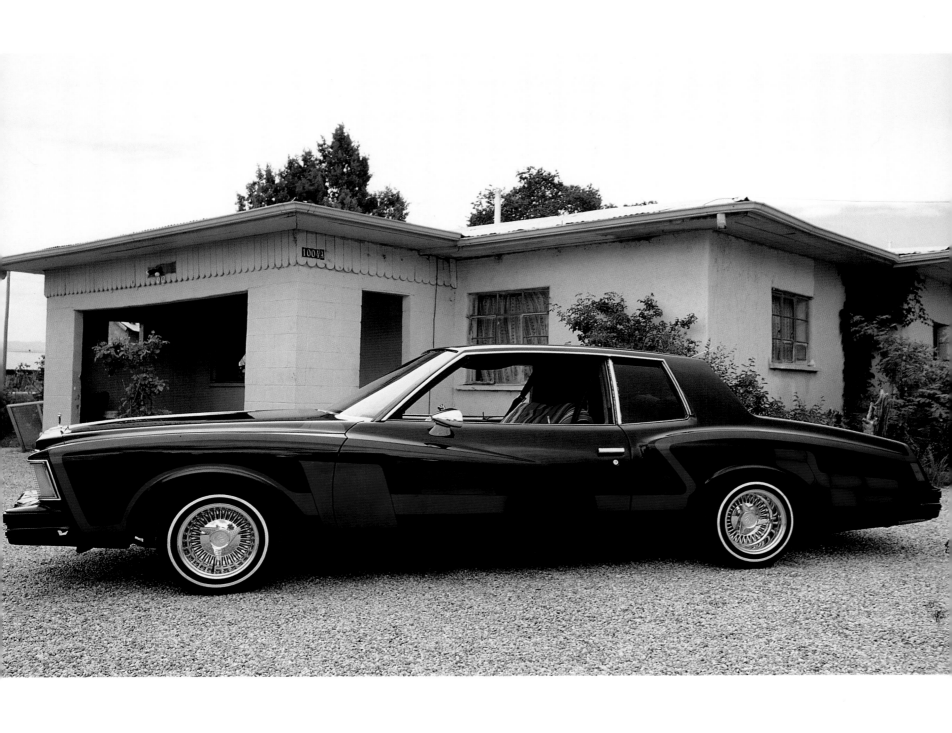

'78 Chevy Monte Carlo
Owner Annette Gonzales of Fairview

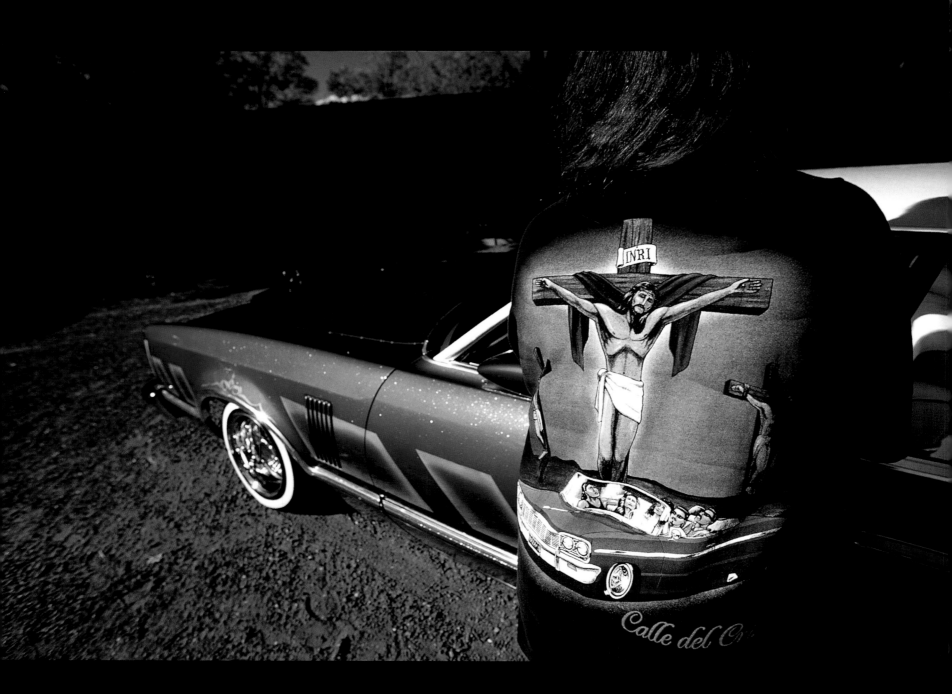

Lowriders in Love

When Lee Córdova met Bettie Martinez in 1984. both had a thing for cars. The only problem. Lee recalls. was that "she liked to go to the lowrider car shows. and I liked the drag races. Lowriders didn't interest me at all."

But the Alcalde couple liked each other enough to accept their differences. When Bettie got her 1978 Ford Thunderbird and began transforming it into the teal-green lowrider of her dreams. Lee gave his support. When the two married in 1989. he accepted that lowriders would always be a part of Bettie's life.

Yet Bettie wanted lowriders to be part of their lives together. Driving home from Santa Fe one day. she convinced Lee to check out a '63 Impala. She loved the car. He wasn't impressed. A few weeks later. though. Bettie persuaded him to ask the car's owner to reduce the price. Lee talked the man into taking $2.ccc off and was so pleased

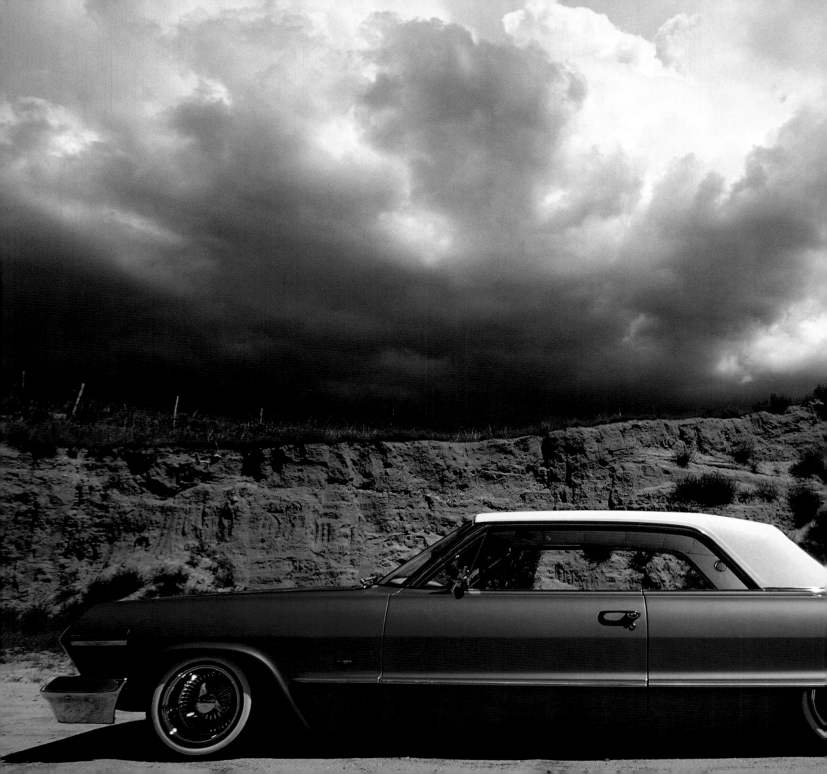

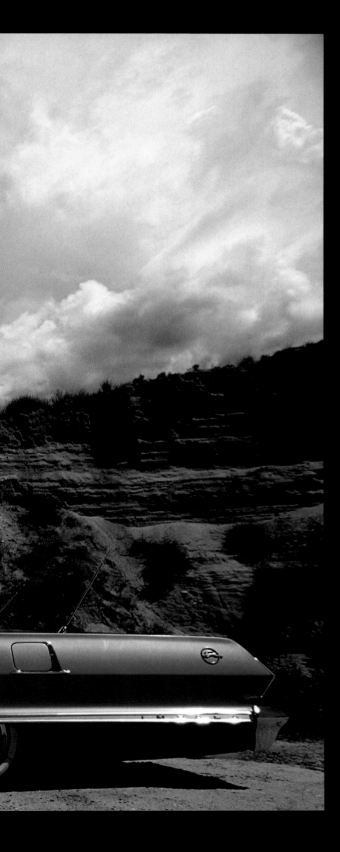

"It got to where I hated to see the UPS man coming," Bettie recalls.

"I got extremely carried away," Lee concedes.

Still, Bettie wasn't about to put a damper on Lee's enthusiasm. She suggested they join Classic Creations, a local car club, and begin exhibiting their cars at area car shows. In 1997, their Impala placed first in its category at an Albuquerque show. But the best prize, Bettie says, is the special bond the car has created between them.

"The car has made us closer in our marriage," she says. "We're lowriders in love."

'63 Chevy Impala
Owner Lee Córdova of Alcalde

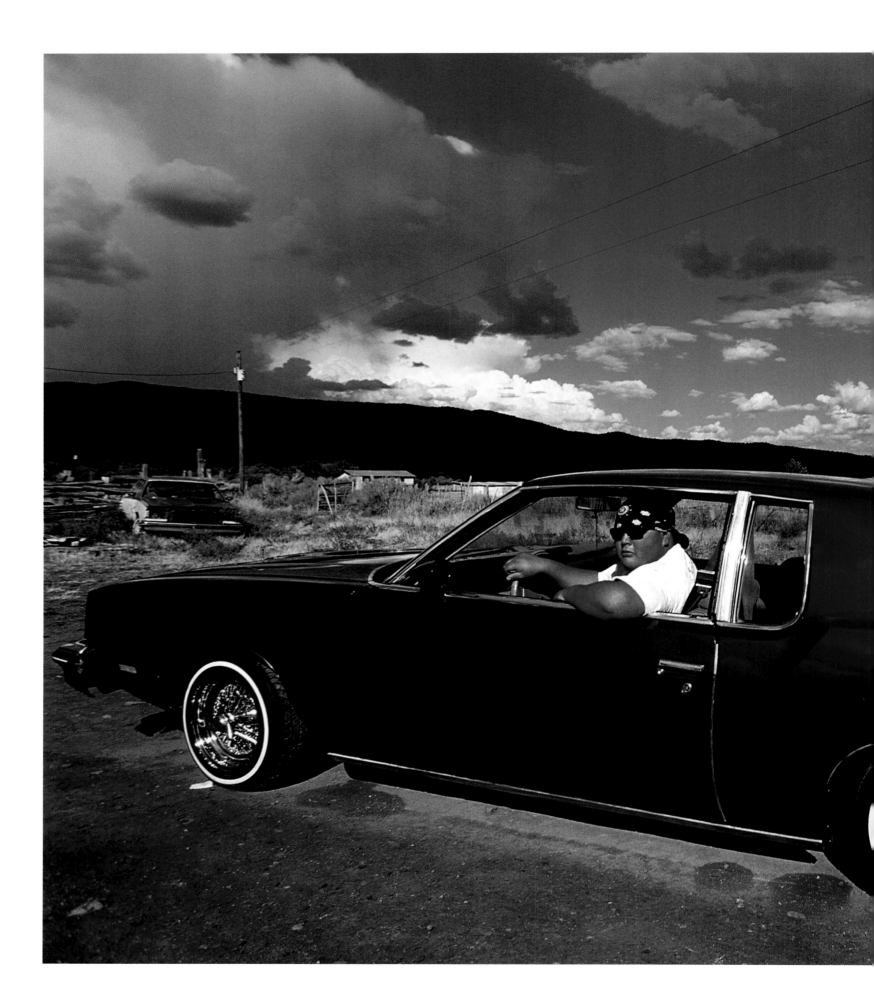

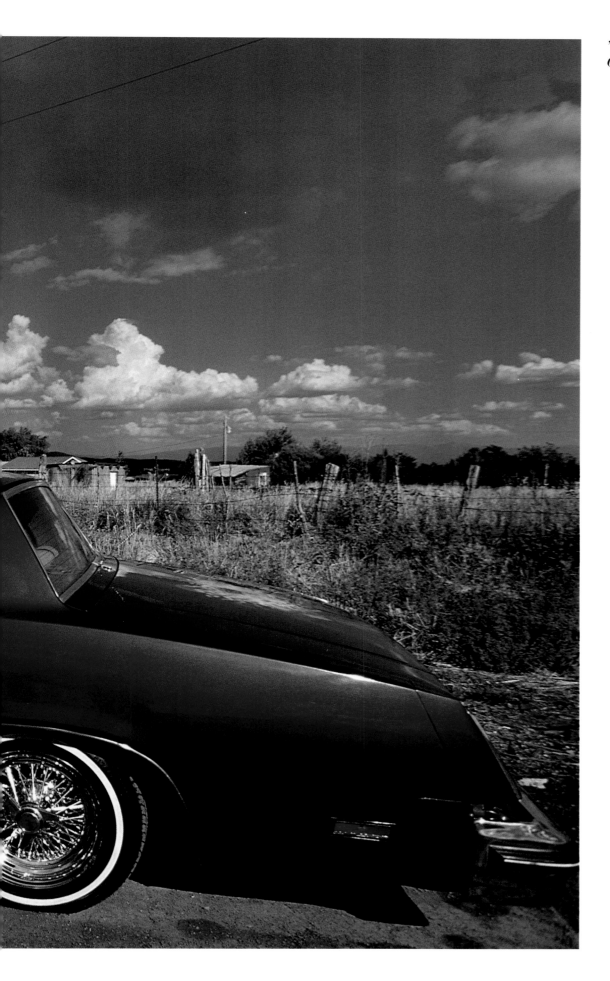

'78 Olds Cutlass
Owner Adam Alire of El Rito

La eché en un Carrito
by Juan Estevan Arellano

"Don't you worry," *retumba la radio del* "Carrito Paseado" *as la plebe, el vato loco del arroyo del rutututú* puff on their Camel, *soltando "rueditas de amor."*

As they huff and they puff the '57 Chevy jumps up and down and sways from side to side up Riverside Lane in *"España,"* after driving down from *"Chima,"* the Capital of Lowriders *en el norte.*

Chimayó, the village known to historians and folkorists for its pilgrimage during *Semana Santa,* and to the cops in *el norte* as the heaven of *tecatos* and overdoses. Chimayó, famous for its *chile* and *manzanas,* now also famous for its wrought iron windows and doors so the *tecatos,* not the lowriders, can't enter.

But who's a lowrider, *el chavalo de la* Molly in his '64 Impala *de la llantas peladas* in his low and slow rider, with the torn seat covers and the *rosario* hanging from the rearview mirror, or the *vato que no está tan loco* who works in Los Alamos as a machinist and is already a granpa?

Birdie, *el "Colora'o" de la* Tonie (she worked at the Motor Vehicle for years in *Santa*), is a lowrider and a biker, a Harley *ese, de esas chingonas,* like the horses his *abuelo* used to own. In fact, there would be no lowriders if the *jefitos* would not have been so *aficionados de los caballos.*

The people in *Cañoncito* still remember "Lalito" and his *yegüita la* "Nellie," whom he had decorated with all kinds of reflectors and pieces of chrome all over the saddle and *freno.* In fact when "Nellie" was burned inside her corral by some wise-ass who was never caught he would get upset *si no le dabas el pésame!*

Then he got himself his first lowrider bike, back in the late '50s before *Lowrider* magazine; he decorated his bike like he did "Nellie," with chrome and reflectors all over. *Lalo* the Irundian of the Chicanos could be seen all over *el norte,* at times he was peddling to Taos, or he would be seen by the Opera by *Santa* or in *Abiquiú,* resting in the shadow of *"el Pedernal,"* the vagabond mountain on the *Río Chama.*

It was with "Lalo," that my *cuñados,* brothers-in-law—or "cunnies," as Casías would say—got their initiation into the lowrider *movida,* modeling their *baiques* on his twenty-six-inch cruiser, then when they came back from Nam and *Lalo* had gone to a nursing home, they would always evoke his name as if he was a saint, the saint of the lowriders, as they would reminisce about "Lalito's" bike and how he used to decorate it and how that idea came from his horse "Nellie" and the many "nellies" the *jefitos* used to take pride in and their *frenos y sillas flamantitas y bien arregladitas.*

That same culture of always making the horse something to be proud of, of having the most *chingón caballo* somehow transferred from their *jefitos'* and *abuelitos'* generations to their Model A and Model Ts and later to the '57 Chevy or the '64 Impala, '72 Monte Carlo and so on. The *carro aplanado,* had replaced the *caballo paseado,* but the pace was still low and slow.

Today the lowrider holds on to his culture through his lowrider car, *la ranfla de ayer, descendiente de los primeros caballos* that Oñate brought with him to the Española Valley in 1598, *el carrito pasea'o* has become his traveling art gallery, his museum on wheels, with his

Virgen de Guadalupe on the hood of his "Monte" and another one tattooed on his arm, by his first tattoo from junior high where he crudely scribbled "Mom + Dad" and "l-o-v-e" on his knuckles and the faded letters of his first girl, "Linda," now married to the sheriff, the one who gave him a DWI about ten years ago, when he used to drink *bironga.*

Hoy todavía le caen sus gallazos, sus buenos toques, todavía es miembro de la sociedad del cartucho aunque ya no está activo en la sociedad del corcho. "Drinking was getting me into a lot of trouble, but a little 'yesquita' in moderation is *fregón.* I can't afford to drink and go cruising in my lowrider. *Me costó mucha feria.* I have about $20,000 invested in my 'mean machine.'"

Before lowriding became a fad, it was the cruisers who made the rounds from burger joint to burger joint in Española, *mirando a las chavalas en su "pantalón blue jean" bien apretaditos, wachando aquellas curvias de bajada y yo sin brecas, la Rachel, la Margo, la Maggie,* and all the rest of the *chulas de Chima, Truchas, 'l Alcalde, 'l Dique, de todos los* towns.

On weekends you find most of the *vatos,* now some of them are getting to be *rucos,* well, not really *rucos* like *los abuelitos o los tíos,* but the reality is that they are now "granpas" and *tíos;* not too long ago they were *estudiantes en el* "community college" *en El Rito y en el TVI en 'Burque.*

La Maggie, te acuerdas, she was *cuerota, que cuerpito tenía* and now she is all fat, *pobrecita, con las nalgas sueltas y guangas* and when she walks her twenty-four-inch waist of the early '70s now moves ("chacualea") like a jello hula hoop.

But today she is no longer *la chuca de* Taos she was then, when she would dance away the nights at *Los Compadres* and *La Cucaracha* drinking *Cuba Libres* and chasing them down with Coors, from the land of clear blue waters, *ella y la* Black Widow *tirando chancla toda la noche esperando la movida, en la espeta mientras tocaba el Silas, pobrecito ya murió,* and he would say, "Is everybody happy?" then as he got ready to play the last *rola* he would blurt out, "Motel time, motel time, *plebe!*"

That night, *el último bolote, lo bailó bien pegadita con el* Tom, she danced like she had never danced before and after the dance they went for a cruise in his '57 Chevy with four on the floor, with its brand new 350 engine, *la* Black Widow *también fue con su camarada el* "Rock," they had a couple of more six bangers and two homegrown *frajos de la morada y se pusieron bien carmelitos, ni pa' que te cuento.*

In the *movida*, between kisses, they realized they were both students *en* El Rito, he was studying auto mechanics and auto repair—a double major, *ese*—and she was in cosmetology. That Monday he went so she could *"trimearle la greña"* and the rest, as they say, is history. Now they've been married for twenty years, though they have a twenty-four-year-old *chavala*, who has two kids. Oh *ya*, they also "shacked up" for four years. The *ruquitos* of the generation said they were *"amancebados"* and the ones that used to bathe the *padre*, the *"padreras,"* as they were called, said, *"están viviendo en pecado,"* though everyone in the community knew about their *movida* with the *cura*.

"*El Padre Jesusito es muerto,*" they would say, in reference to an old *chiste de la plebe* about this lady that used to

have an affair with the village priest, and one day as Carmelita was walking to town she found a penis, full of sand by the convent, and she became hysterical and started lamenting, *"el Padre Jesusito es muerto,"* before she realized the penis belonged to an old haggard dog.

A quarter century later *todavía están enchanta'os aunque* both have played around, that is, both had lovers during the early part of their relationship, *él con la* Peggy who is now a nurse in Española—she is still single and beautiful—*y ella con el compadre Tacho,* but now they're all *"chales,"* very quiet, married, devoted to their families and their lowrider lifestyle.

On two different occasions Tom's car (though his real name is *Tomás León*) has graced the pages of *Lowrider* magazine, *con unas chavotas casi encueradas untadas como mantequilla sobre la pobre Virgen de Guadalupe,* and he has won countless trophies for his souped-up car.

In a way one could say that his car was salvaged from the boneyard at his *primo's.* He bought it from him while he was still in high school and started fixing it up until it became his *"carrucha,"* or *"ranfla,"* as *la plebe* would say. First thing he did was get some "mags *de puro chrome"* and for a long time he had it primed, all through high school, then one fateful day, a few days before graduation *de Santa Cruz,* he got a letter from the Selective Service telling him to report for duty in Fort Bliss—his lottery number had been thirty-nine—and he had been expecting it for some time. From '69 to '71 he was in the service and spent nine months *"en el infierno,"* as he called Vietnam.

He came back *"todo chinga'o"* and got worse when he realized his babe

Priscilla had married his best *camarada* Felipe—he was devastated *y le entró a la peda, grifa y coca,* well, he came hooked on *"la soda, de aquel la'o,"* as his parents would say.

Maggie, she was a cheerleader for the Peñasco Panthers during her freshmen year and a varsity cheerleader for the Taos Tigers during her sophomore, junior, and senior years, that is, she moved to Taos with her mother after she divorced her father the summer of '70. Her *jefita* was from *Ranchos*, that summer her mother, two brothers, and herself moved into an old mobile home her granpa owned in the middle of the *vega* where his father at one time used to plant wheat, then later on he used to plant white corn, *"maíz concho," el propio para chicos.* But as he got older he stopped planting and the *rastrajo* eventually returned to *vega*.

The old '57 is now on four piñon stumps out back, while the second '57 he bought after he returned from Nam is his son's, Manuel or "Manny," the one he now uses to cruise his dad's old stomping grounds in Española, Santa, and Taos. His dad, now that he is middle aged and a granpa, has two lowriders, a pickup '51 Chevy all "cherried" out for show and a '74 Monte that used to belong to an old retired lab worker in Los Alamos.

Not much has changed *"en España"*; the kids still cruise from Sonic to Sonic, their boom boxes awakening even the dead *en el Campo Santo,* here in the valley *de los españoles-mexicanos,* where the first *fregones caballos* were nurtured by Oñate. Today his descendants fix up old cars and turn them into works of art, *del modo que los abuelitos engordaban un potrillo flaco hasta que lo hacían el mejor de todo el atajo.*

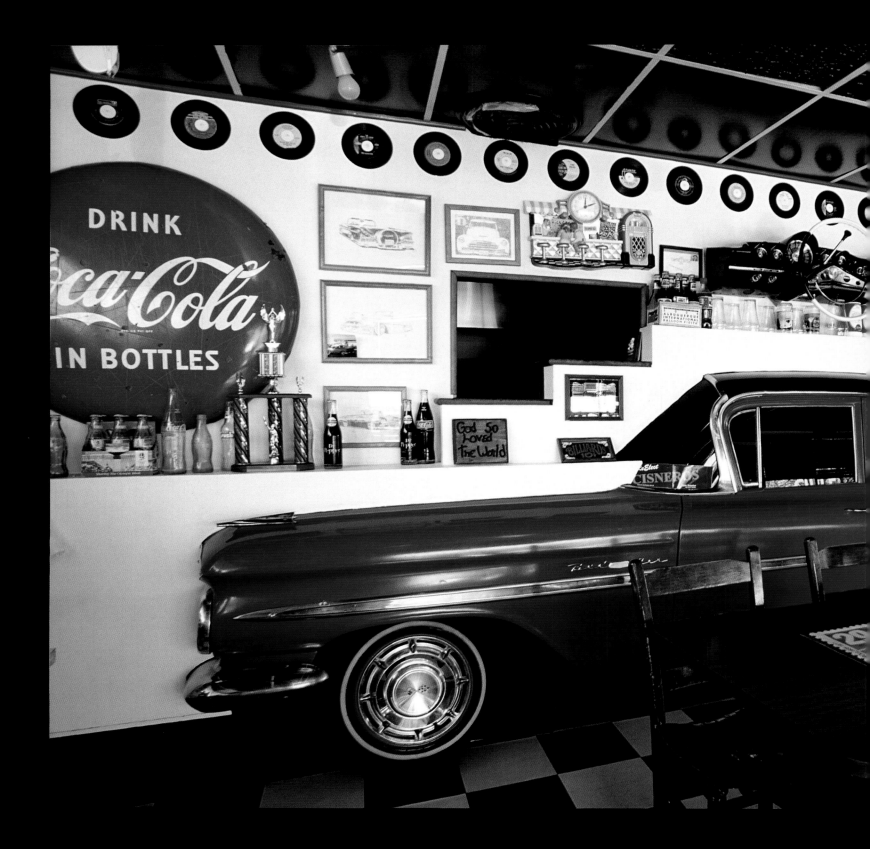

'59 Chevy Bel Air
Owner Fred Rael of Fairview

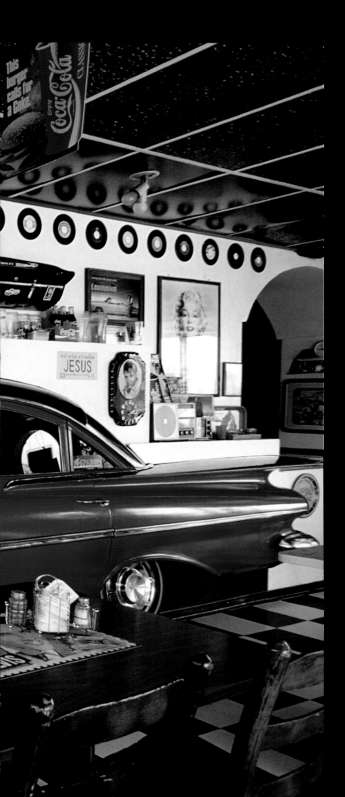

"**W**hen he first told me he was going to be a lowrider. I cried." Olivama Rael says. motioning across the table to her son. Fred. "I went to my prayer-book leader and said. 'I need prayer. My son's going to be a lowrider.'"

It is just before the dinner rush at Ol's Diner in Española. the Rael family business. The Raels are remembering when "lowrider" was a dirty word in their home. It was 1977. and Olivama and her children had just moved back to their native New Mexico from Los Angeles. Mom took a job as a waitress. and thirteen-year-old Fred began showing an interest in cars.

"When we came to Española. I heard that lowriders were really bad. and like everybody else. I believed it." Olivama continues. "But my prayer-book leader asked me if I'd rather Fred spend his money on liquor and drugs. He said if he spends his money on his car. it's a blessing in disguise."

As Fred immersed himself in the how-tos of bodywork. mechanics. upholstery. and other lowrider luxuries. Olivama slowly converted to the lowrider faith. By 1983. when she bought Ol's Diner. a 1950s-style burger joint. she was so enamored with lowriders that she had Fred install one in the dining room. He sawed a 1959 Chevy Bel Air lengthwise in half. painted it cherry red with a black top. and bolted it to the wall. "A lot of people think lowriders are immature." Fred says. "but they're an art form."

Situated on Riverside Drive. Española's main drag. Ol's is now a popular hangout for lowriders who come from all over Northern New

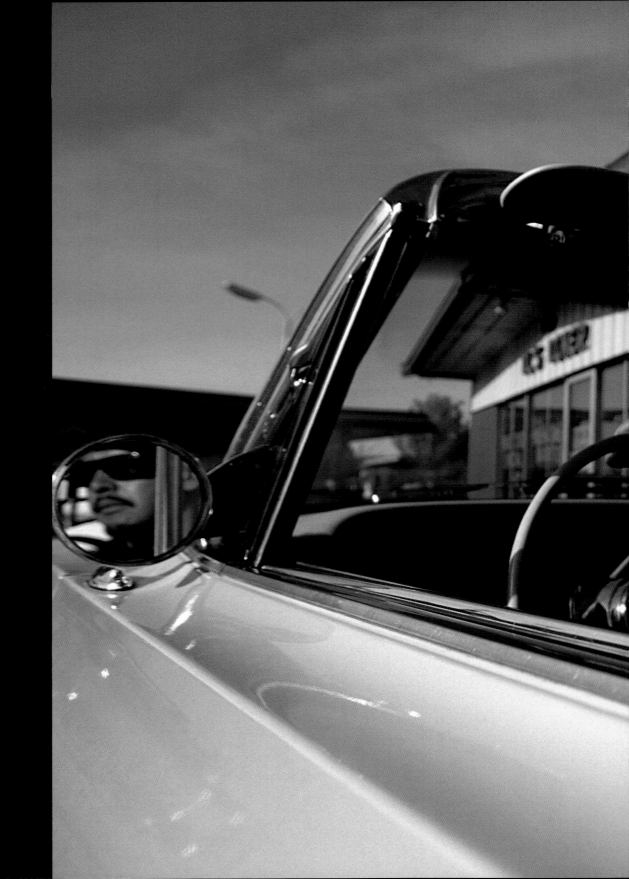

*'64 Chevy Impala
Owner Fred Rael of Fairview*

Mexico to cruise. When Fred's not navigating his '64 beige Impala convertible—complete with 24-carat gold rims—through city streets, he and Olivama are at the restaurant enjoying the view.

"When I see a nice lowrider pass by, it makes my day," Fred says. "But if it doesn't scrape the pavement, it's not a lowrider. It's just another car with rims."

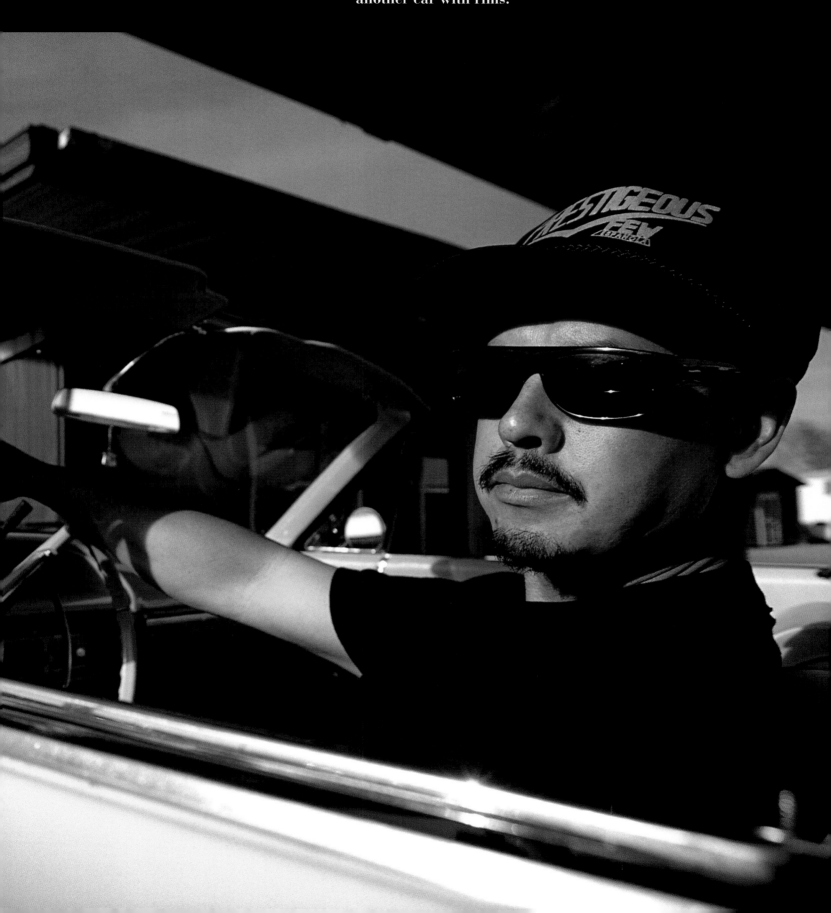

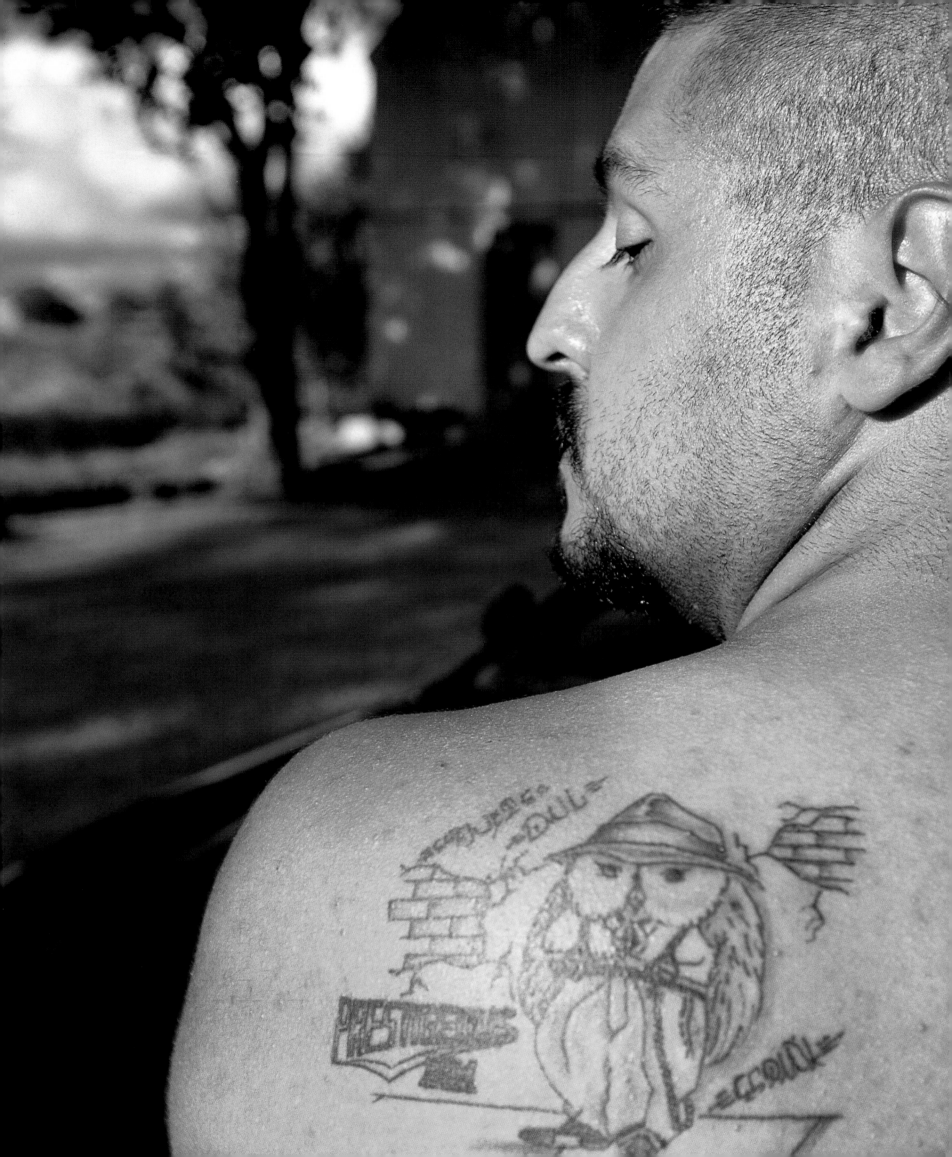

Night Owl

'95 Honda Civic
Owner Carlos Sanchez of Española

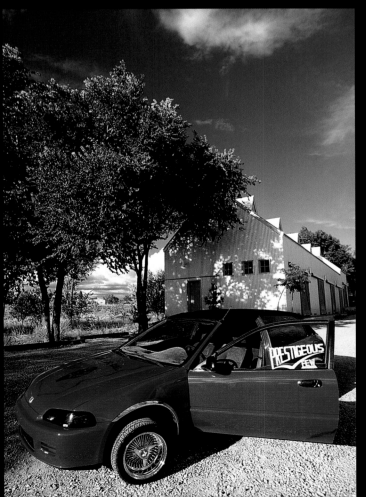

As a kid in Los Angeles, Carlos Sanchez was known as "the Night Owl" because he often snuck out of the house at night to roam city streets. Sanchez and his late-night companions weren't out to cause trouble, but the fact that they were young Hispanics made them prime candidates for the "gangbanger" label. Their love for lowriders set them up for the stereotype even more.

When Sanchez later moved to Española, he was thrilled to see its flourishing lowrider culture but disappointed that the lowrider–gangbanger stereotype still prevailed. Thus, in 1993, after cofounding the "Prestigeous [*sic*] Few" car club, Sanchez set out to change the community's negative views.

"We decided to market ourselves as a community-oriented club," Sanchez says. "We wanted to show people that most lowriders are good people. Most of us are hard workers who have two or three jobs just to stay above water."

Club members organized a car show to raise money for area charities. Convincing city officials to allow the one-day show was difficult at first, but after the charity donations had been made, they welcomed the following year's show. Today it is the largest lowrider show in Northern New Mexico.

"We're more than just a car club that cruises on the weekends: we're like a business," Sanchez says. "But the best part of what we do is show kids that the best way to stay out of trouble is to get into this."

'75 Chevy Monte Carlo
Owner Joseph Jaramillo
of Vallecitos

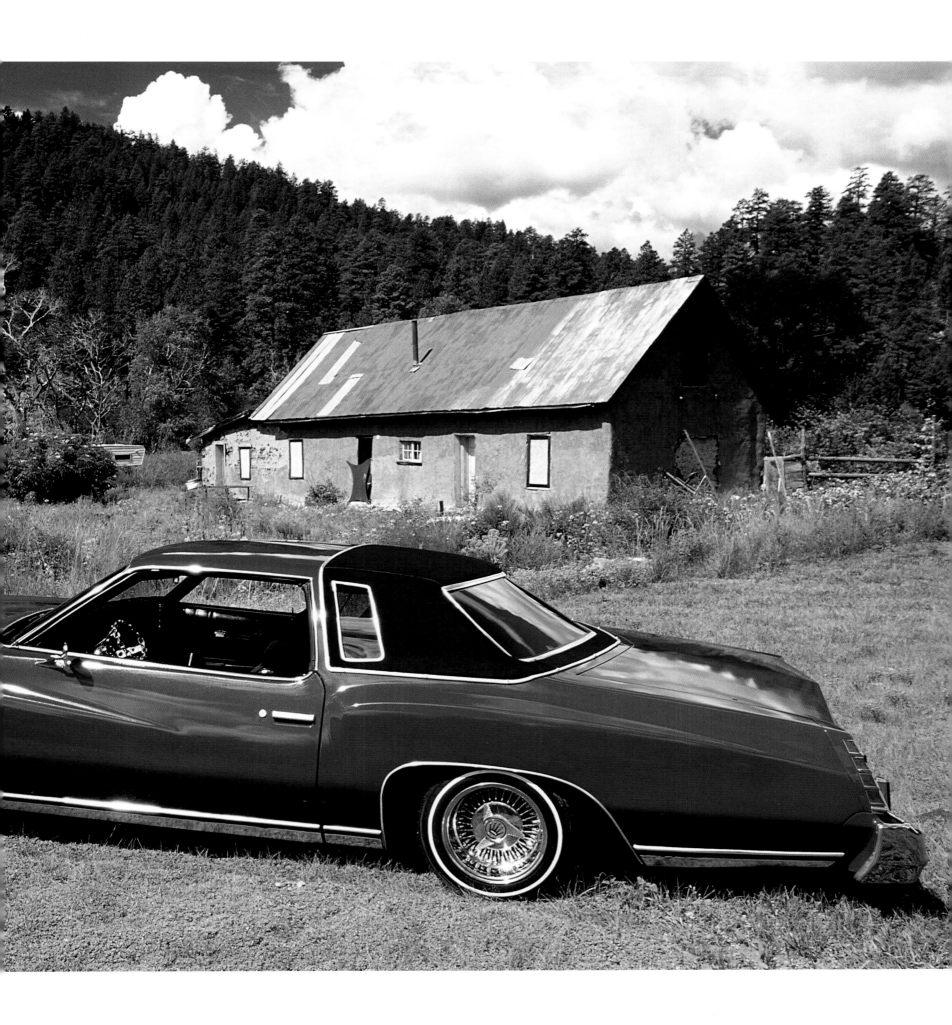

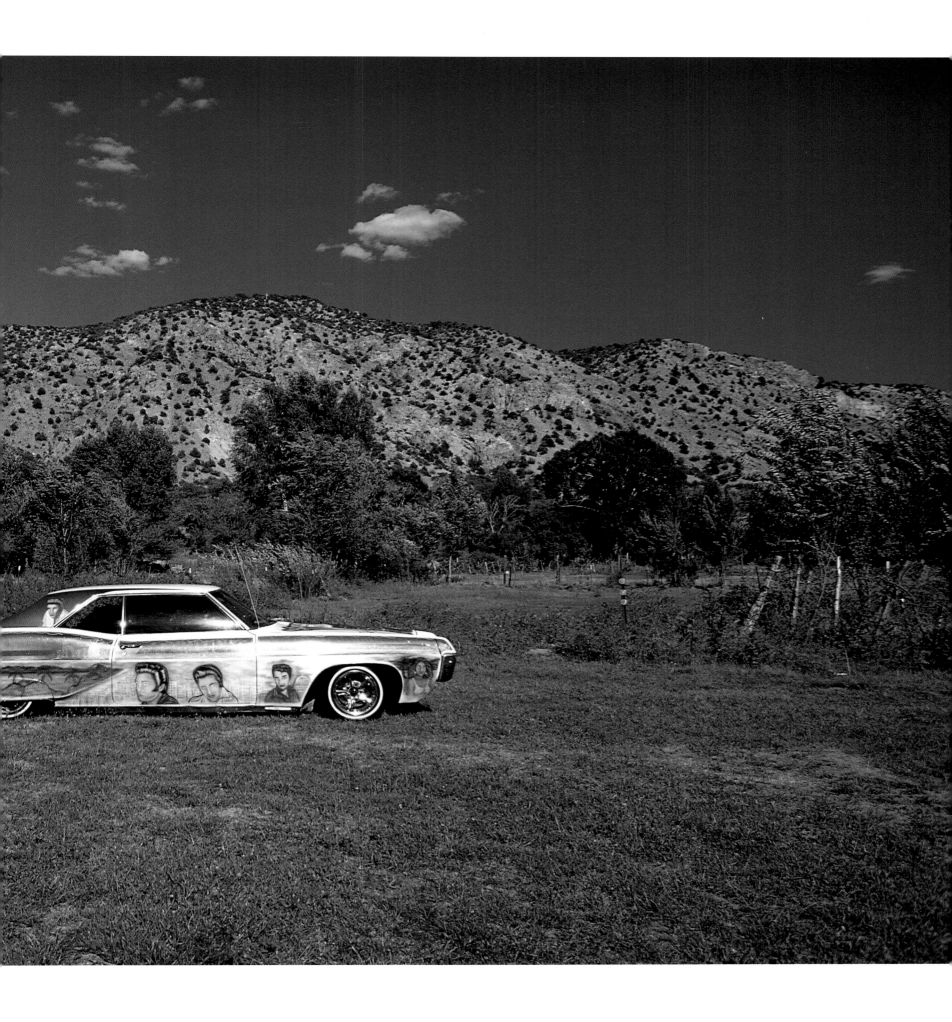

'41 Ford
Owner Melecio Martinez of Santa Cruz

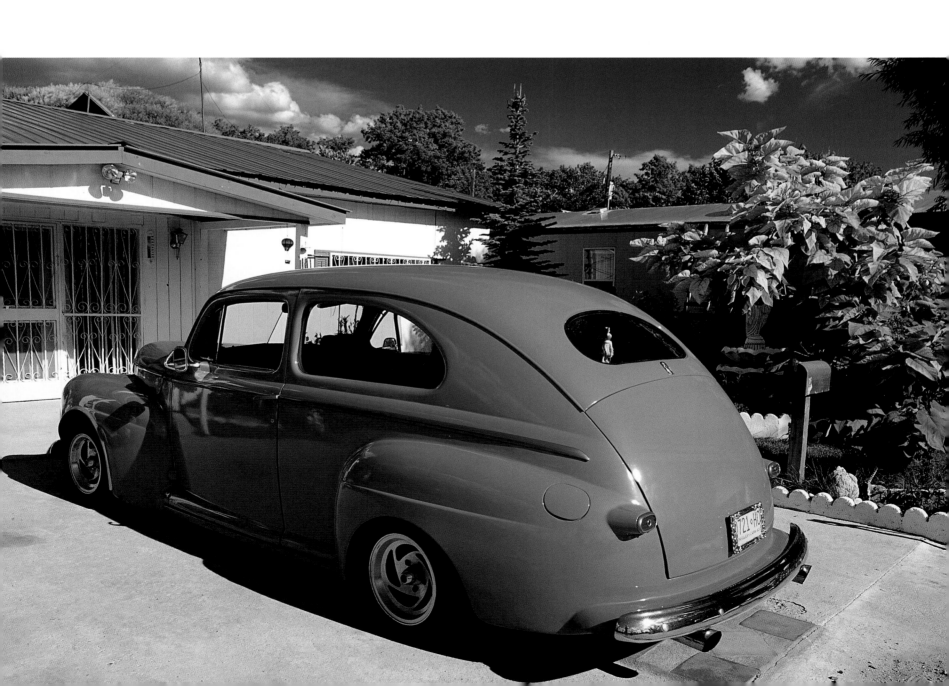

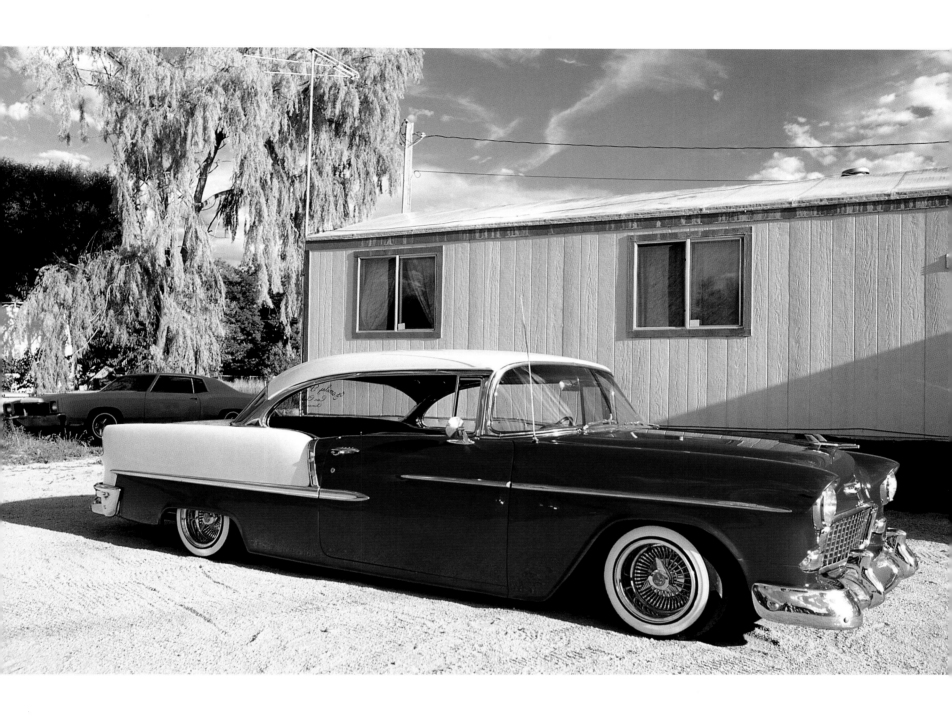

'55 Chevy hardtop
Owner Tony Martinez of Santa Cruz

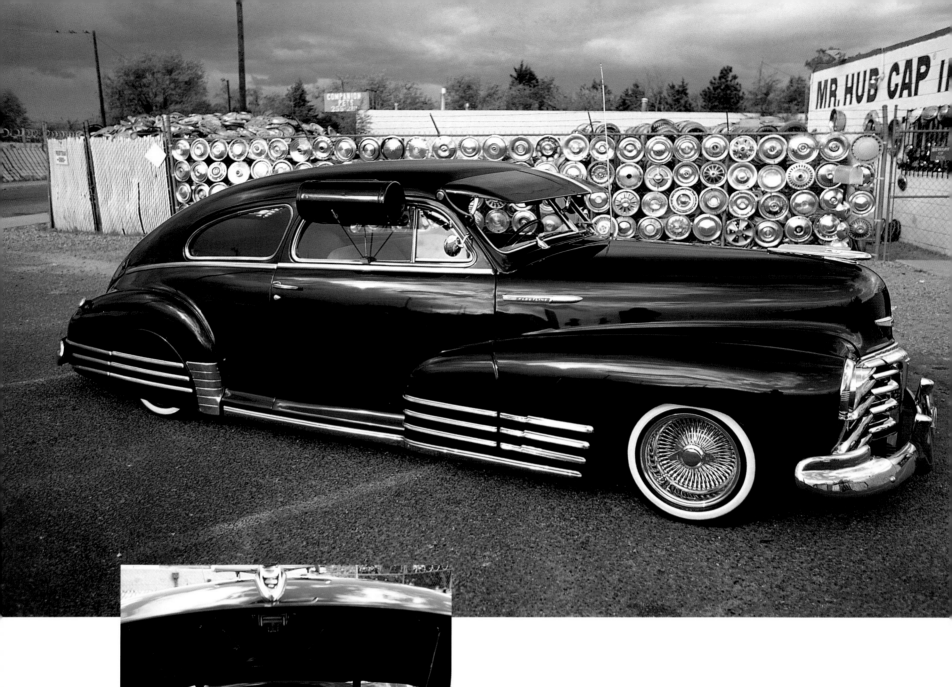

'48 Chevy Fleetline
Owner Jerry Leyba of Albuquerque

'62 Chevy Impala Super Sport
Owner Antonio Gonzales of Socorro

following spreads
'77 Lincoln Continental Mark V
Owner Joe Maestas of Rociada

'59 Ford pickup
Owner Eddie Salazar of Española

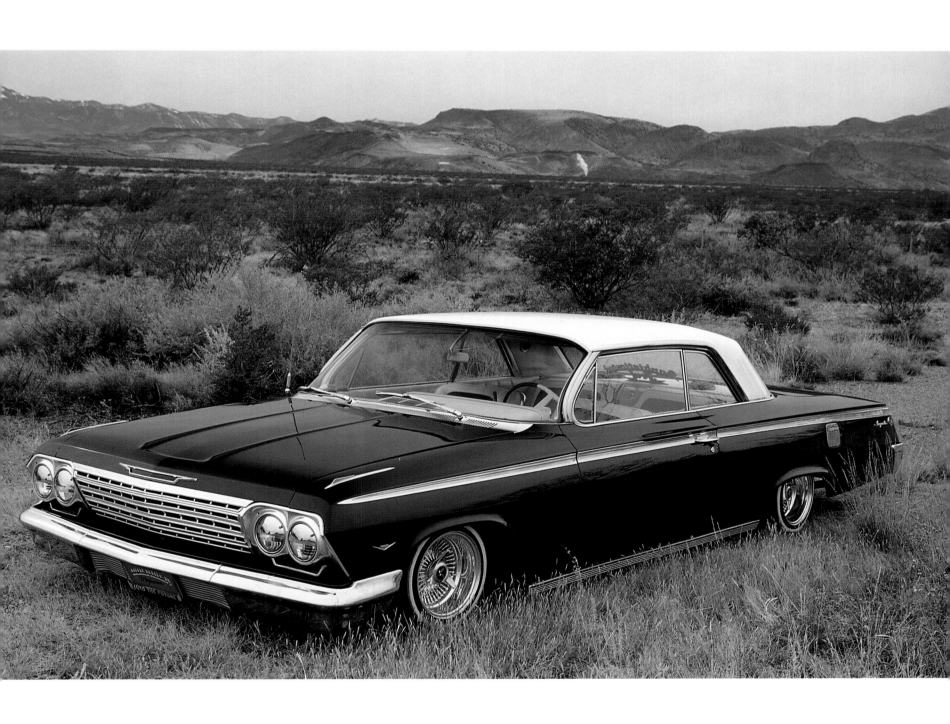

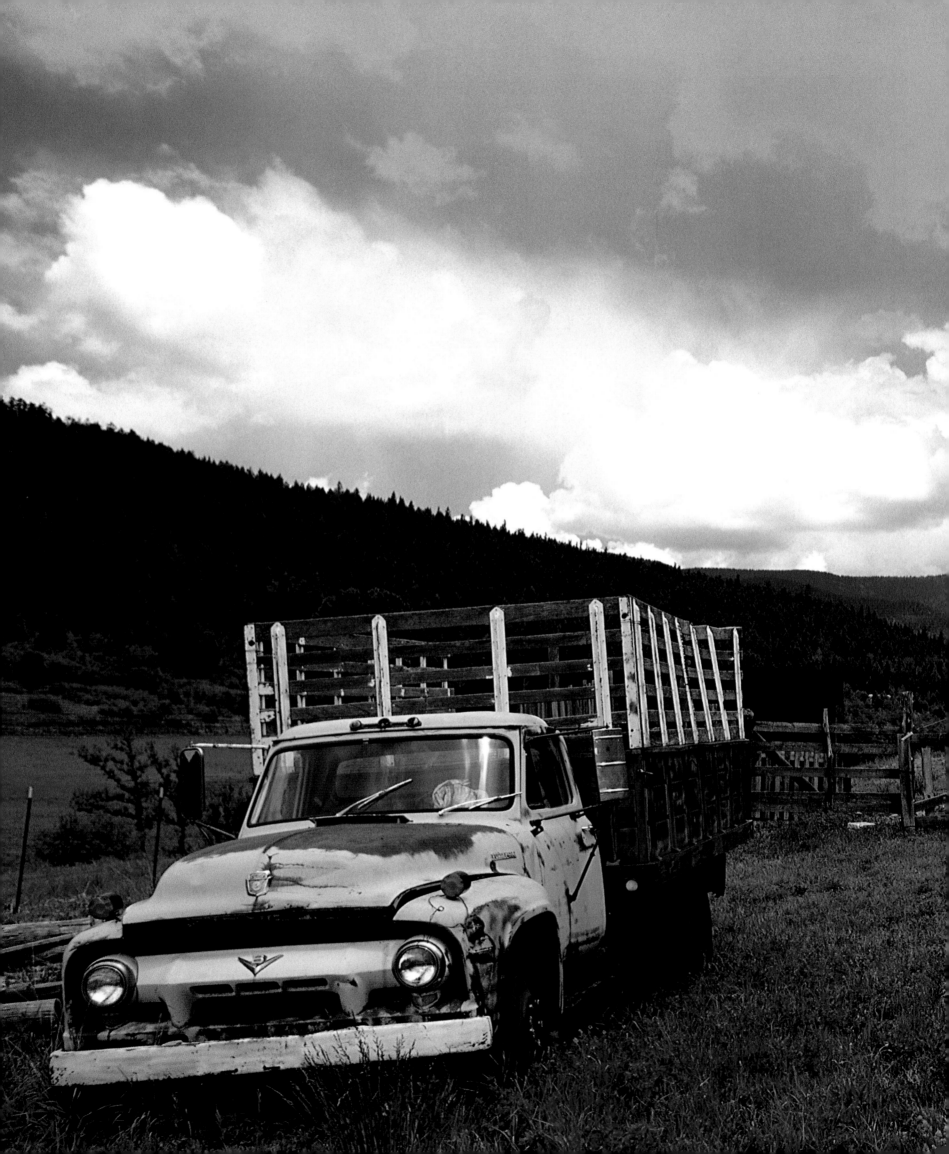

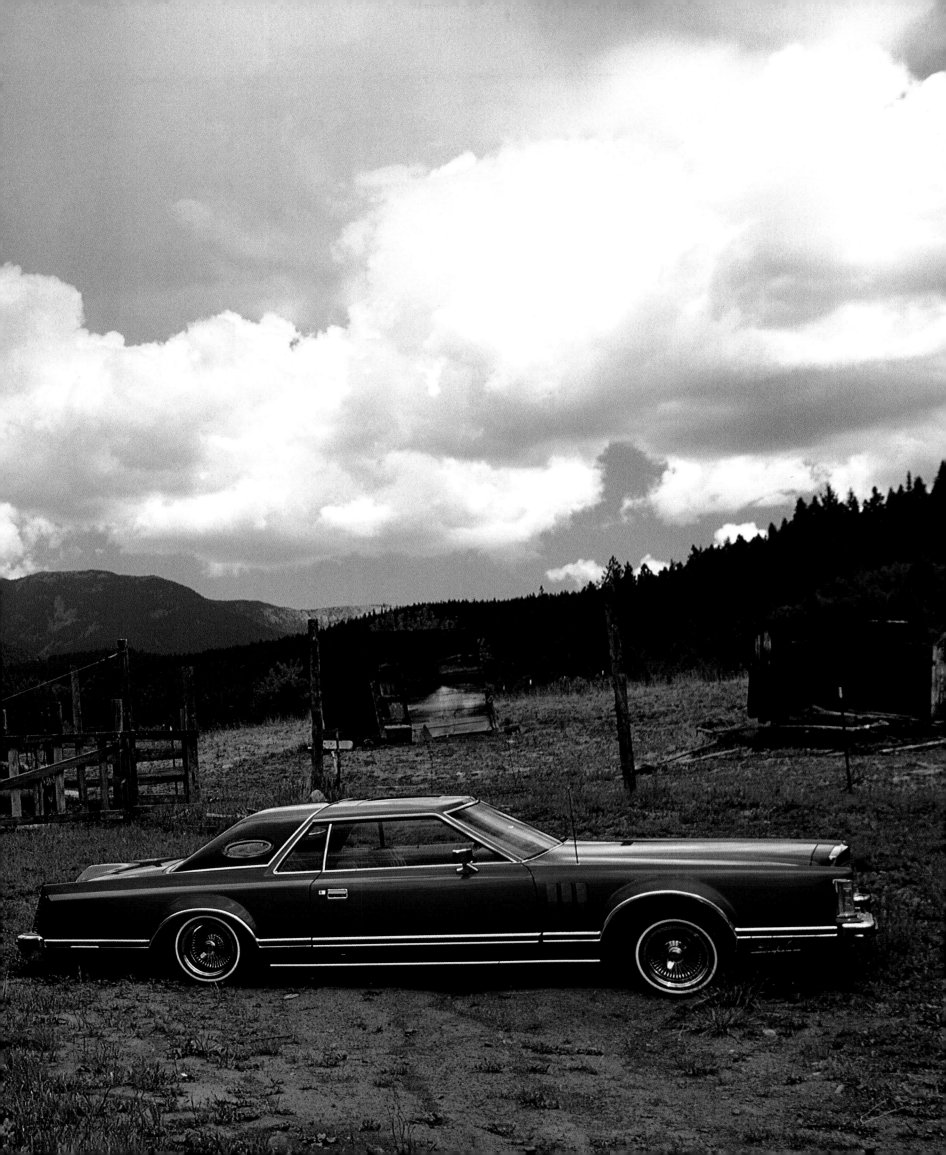

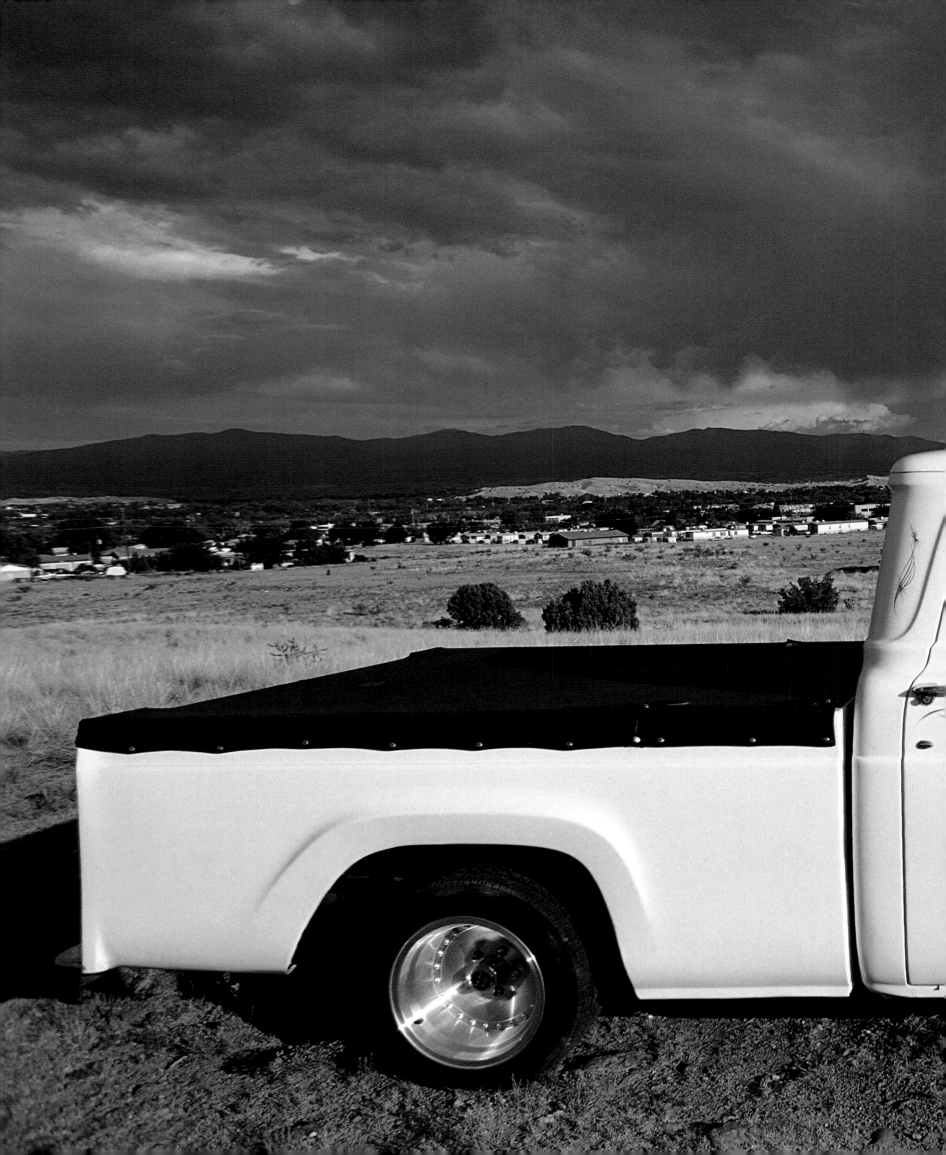

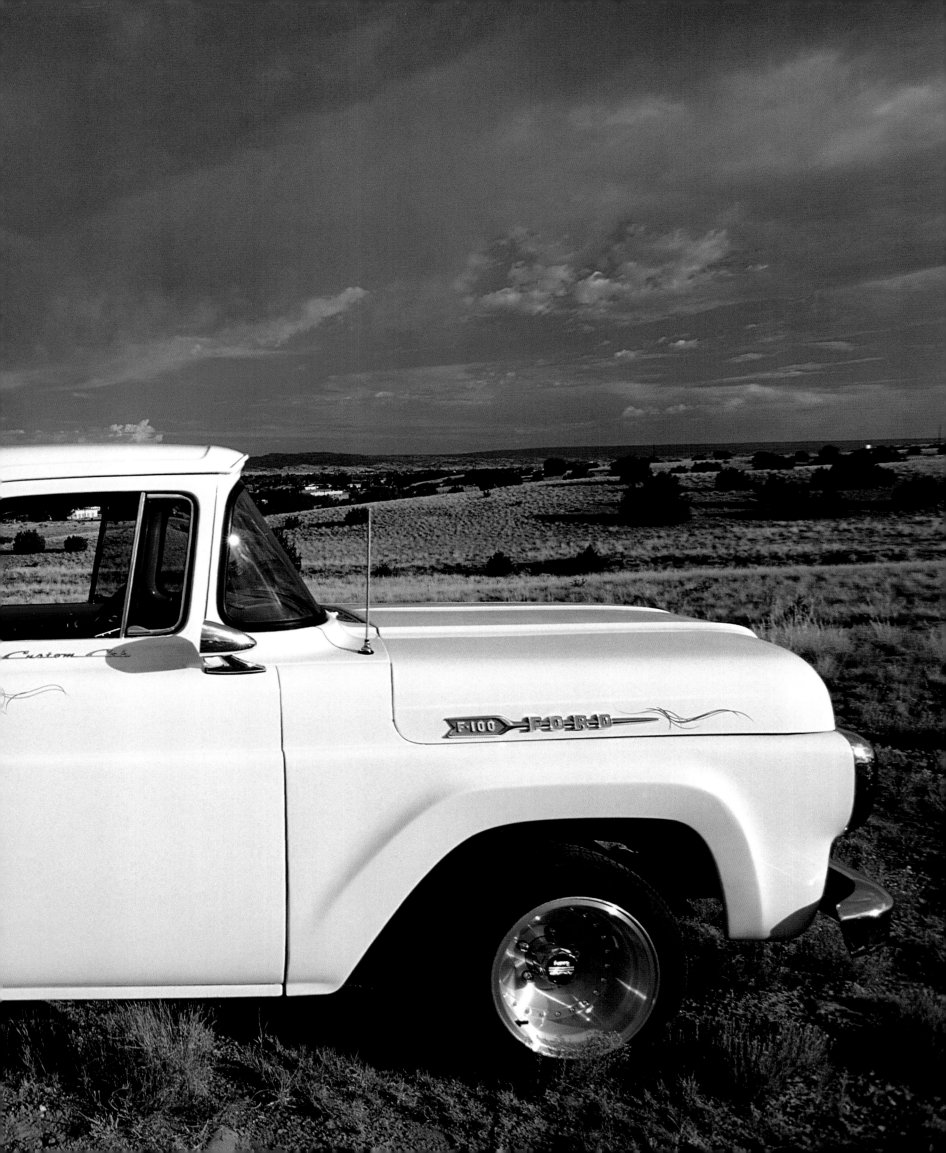

'77 Pontiac Grand Prix
Owner Xavier Nevarez of La Cienega

right
'66 Chevy Impala
Owner Willie Montoya of Los Alamos

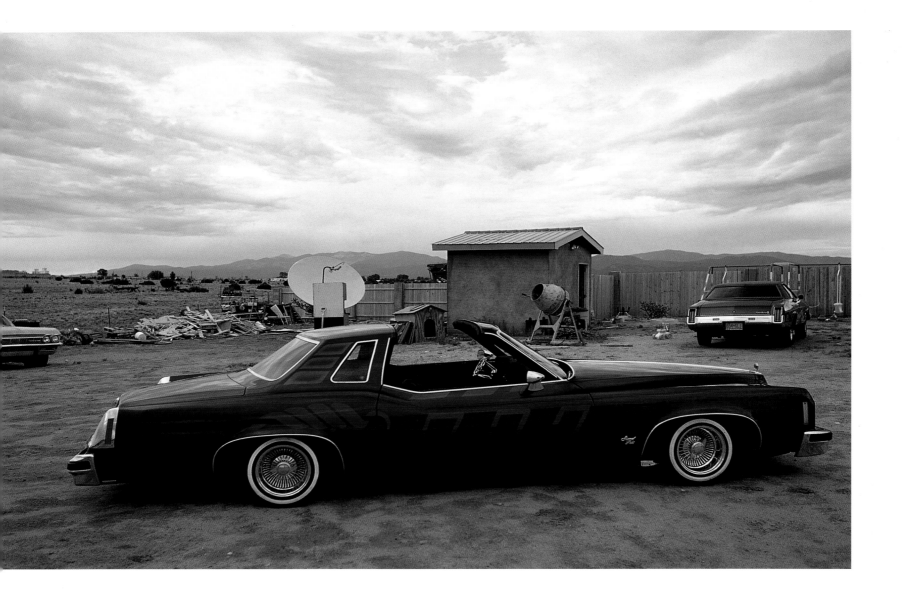

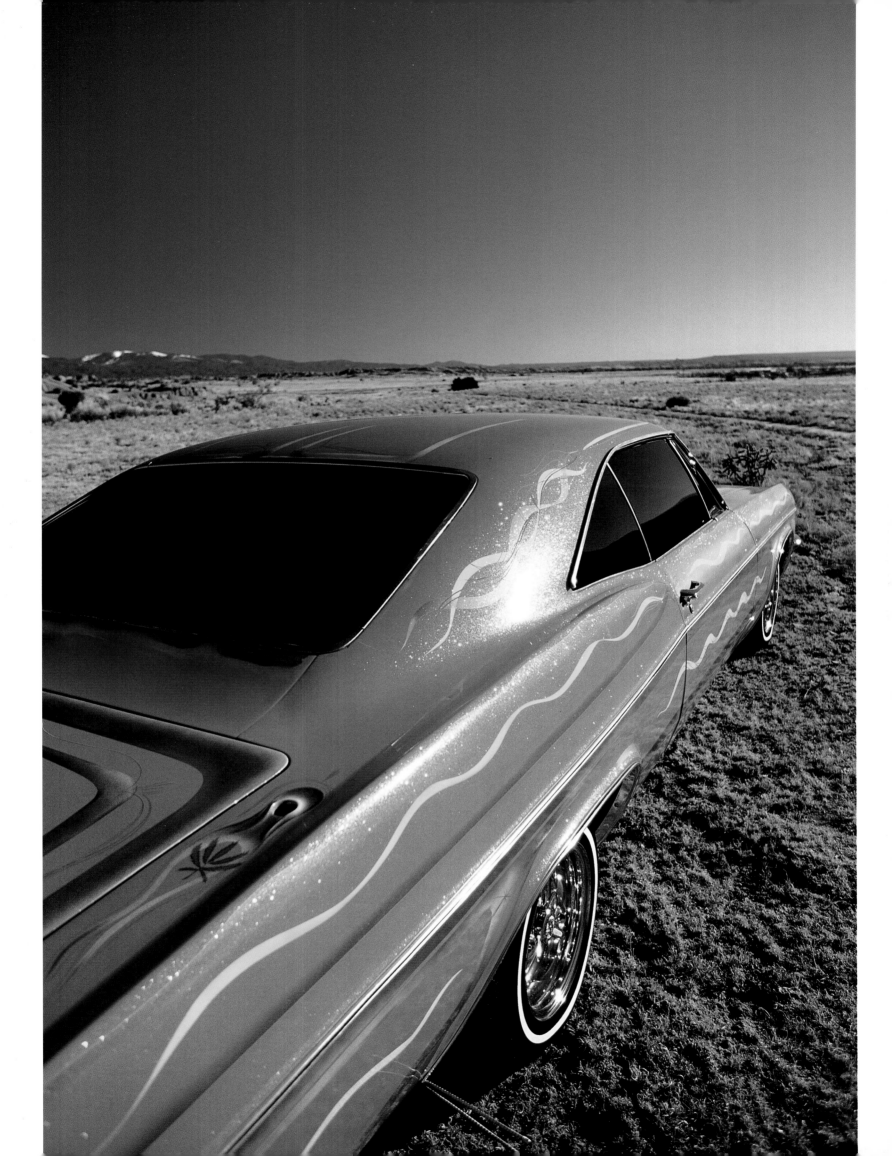

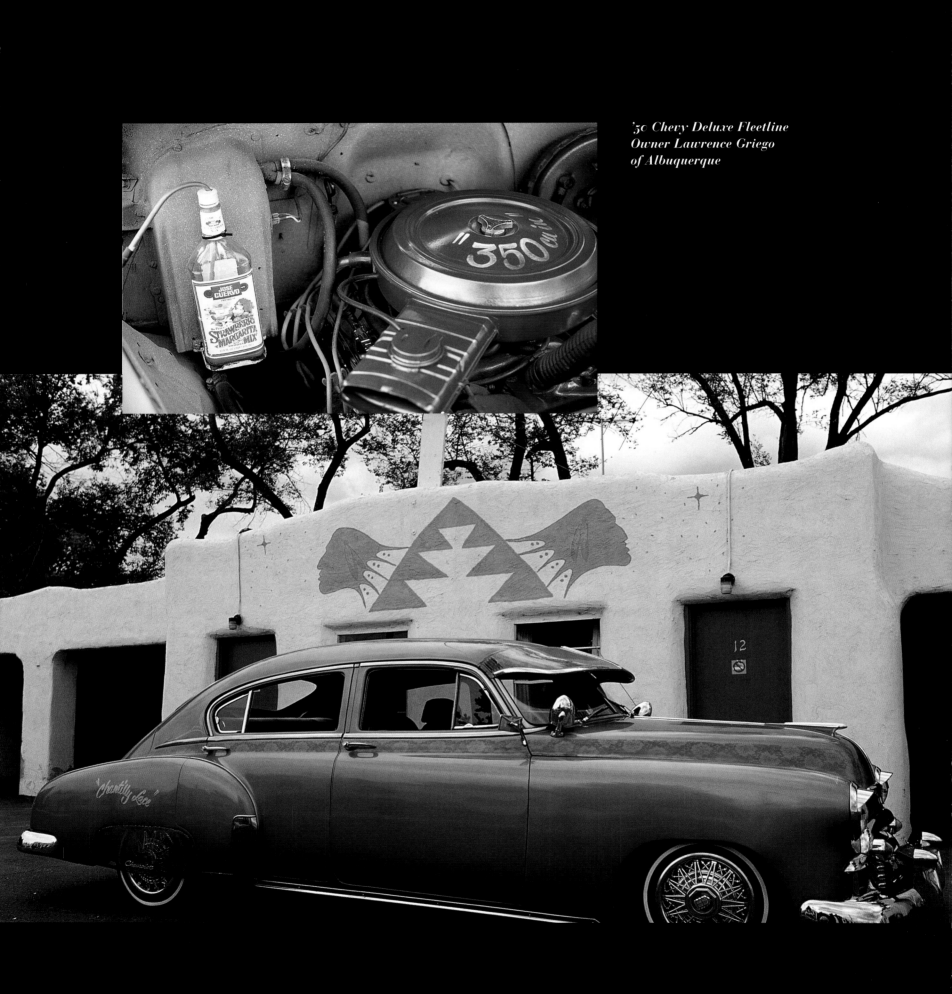

'50 Chevy Deluxe Fleetline
Owner Lawrence Griego
of Albuquerque

Fathers and Sons

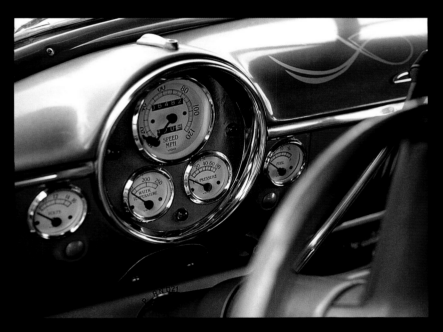

When it comes to cars, Lawrence Griego and his father, Albert, have an unspoken agreement: "He won't mess with one of my cars and I won't mess with one of his cars unless we're together," Lawrence Griego says. "So, basically, we're always together."

With twelve cars between them, the Griegos spend a lot of time in their Albuquerque garage. Lawrence has been taking automotive lessons from his father since he was a boy, and now that he's a father himself, Lawrence has introduced his son to the lowrider life-style.

"Me and my father and my little boy, we're inseparable," Lawrence says. "It's the challenge of restoring these lowriders, to see if we can do it, that keeps this family together." Two fine examples of meeting the challenge are "Chantilly Lace," a 1950 Chevrolet Deluxe Fleetline, and "Glamorous Life," a '64 Chevrolet Impala. After literally digging one car out of an arroyo and hauling the other from a junkyard, they have now spent nearly $30,000 to restore them to their original condition and give them a unique lowrider look.

"All the little $5 items you purchase add up down the road," Lawrence says. "But the way we see it, your car is your personality. The nicer the car, the nicer the person. We're pretty nice people."

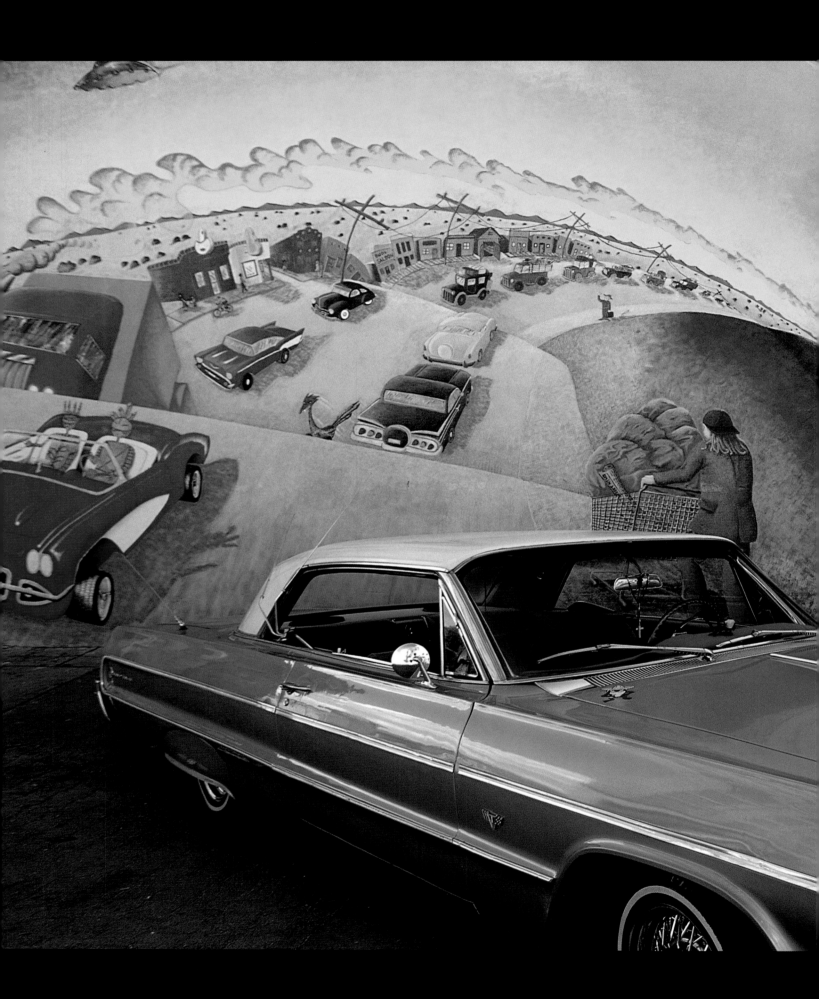

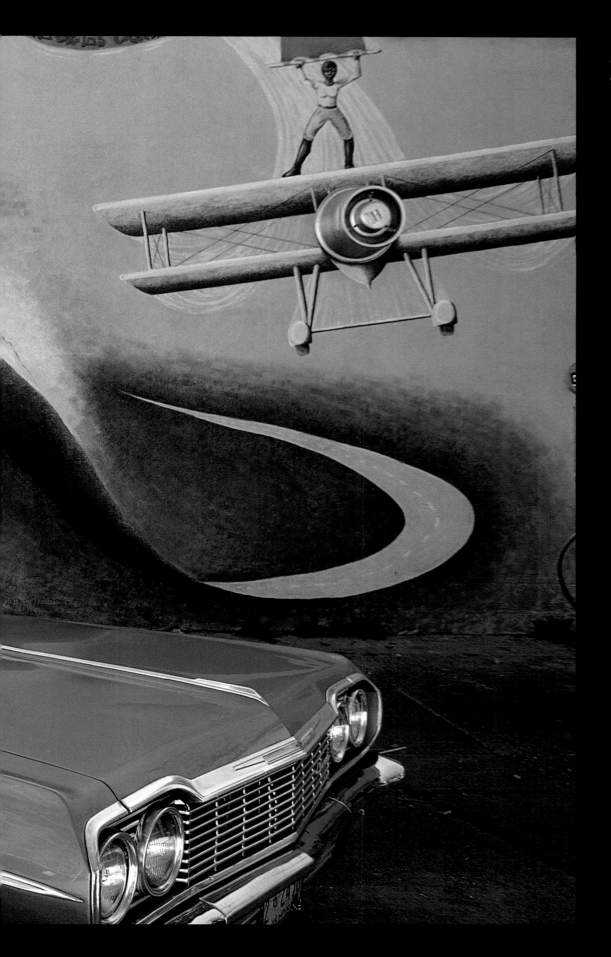

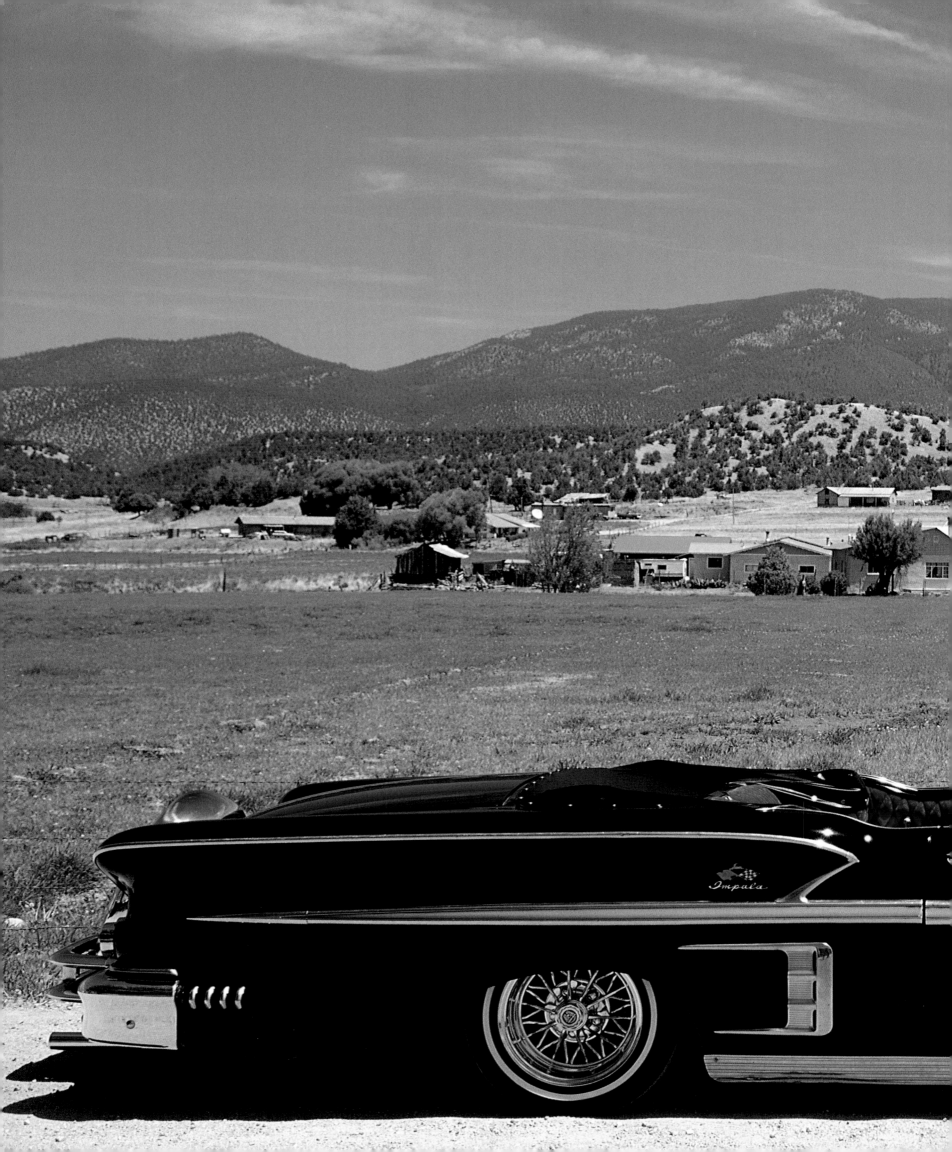

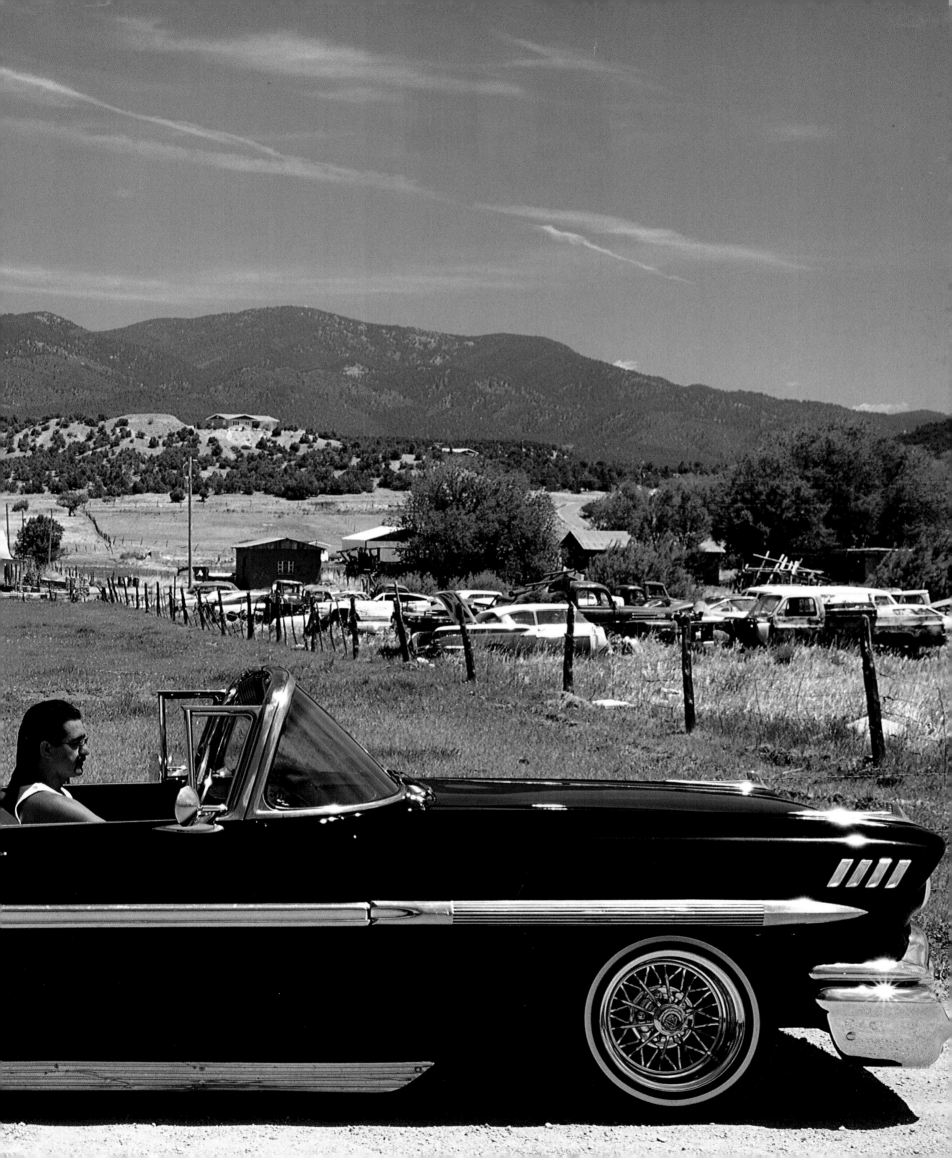

Acknowledgments

All the cars in this book, with one or two exceptions, were photographed at the owners' homes or in the owners' home towns.

I wish to express my thanks to Nicholas Herrera, Carlos Sanchez, and Eddie Gallegos, all of whom helped me find an endless number of cool cars to photograph. Many thanks also to Randy Martinez, a talented painter whose airbrushed creations adorn so many of these wonderful rides. I began to document Martinez's work in the early 1990s and it was through him that my interest in and respect for the art of the New Mexico lowrider grew. Without him, this book would not have happened. Terry Lynch and Brook and Mara Taylor also contributed greatly to this book and their hard work and friendship were invaluable throughout. Thanks also to Meridel Rubenstein, whose portraits of lowriders exhibited in the 1980s have always been a source of inspiration, and to Edward T. Hall, whose insights into different cultures have profoundly altered the way we view the world around us.

—J. P.

The authors also wish to acknowledge Mary Wachs, David Skolkin, Anna Gallegos, and Joanne O'Hare of the Museum of New Mexico Press for their hard work and encouragement throughout the production of this book. Also, a hearty *muchas gracias* to Juan Estevan Arellano, whose distinctive poetic voice gives the book an extra boost of adrenalin and authenticity.

Benito Córdova gave his unique scholarly viewpoint and articulate explanations of lowrider history.

Most importantly, we want to thank the numerous lowriders who generously gave their time, insight, and of course, their incredible cars to countless photography sessions, phone calls, and interviews. Among them are: Adam Alire; Gary Aragon; Steve Aragon; Leroy Baca; Carlos Carrillo; Leonel Chacon; Dennis "Chicago" Chavez; Frank Chavez; Orlando Coca; Lee and Bettie Córdova; Juan Dominguez; Eddie Gallegos; Nick and Antonio Gallegos; Adam Garcia; Louis Garcia; Annette and Arthur Gonzales; Antonio Gonzales; Albert, Lawrence and Jenero Griego; Jerry, Mae, Ryan, and Jerome Gurule; T. J. Gutierrez; Lino Herrera Jr.; Nicholas Herrera; Dion Jaramillo; Joseph Jaramillo; Jerry Leyba; David Lopez; Desi Lopez; Carlos Lucero; David Maes; Joe Maestas; Patrick Maestas; Chris Martinez of Córdova; Chris and Leroy Martinez of Chimayó; Ernest Martinez; Jerry Martinez; Joseph Martinez of Albuquerque; Joseph Martinez of Chimayó; Joseph Martinez of Española; Louis Martinez; Melecio Martinez; Paul F. Martinez; Tony Martinez; Arthur "Lolo" Medina; Floyd Montoya; Junior Montoya; Rhiannon Montoya; Willie Montoya; Lee and Anthony Naranjo; Xavier and Fabian Nevarez; Donald Ocana; Wray Ortiz Jr. and Wray Ortiz Sr.; Rey Ortiz; Clarence Pacheco; Julian Quintana; Fred and Olivama Rael; Jerome Reynolds; Jay Ritter; Atanacio "Tiny" Romero; Joseph Romero; Eddie Salazar; Carlos Sanchez; Norman Sanchez; Eloy and Allen Sandoval; Dean Tafoya; Eddie Tafoya; Arturo Trujillo; Delbert Trujillo; Duane Trujillo; Jerry Trujillo; Leroy Trujillo; Marvin Trujillo; Vince Trujillo; William "Wille" Trujillo; Jose Velarde; Andreas Vigil; and Benny and B. J. Vigil. The following car clubs were also extremely helpful: Classic Creations, Dukes, New Dimension, Prestigeous (sic) Few, Touch of Class, and Xpressions.

previous spread
'58 Chevy Impala
Owner Juan Dominguez of Chamisal

120